CU00963628

In the same series

The Louvre
Paris

© 1994 Éditions Scala
14 bis, rue Berbier du Mets - 75013 Paris

SELECTED WORKS

musée d'Orsay

Vanina Costa
Translated by Bambi Ballard

EDITIONS
SCALA

A note to the reader

No one needs a book to tell them how to enjoy a painting. We are instinctively touched by a smile, dazzled by a colour, impressed by a subject. We like or do not like a painting.
But, once the first impression is over, questions arise, and that is when we need some explanations.

Is it not more enriching to know the pattern of his brush-strokes when admiring Monet's virtuosity? To know that a painting is a flat surface when enjoying Gauguin's exotic imaginings? Or to realize that it was the abandonment of the use of perspective that led painters to prefer painting still lifes at the turn of the century?

Questions do not arise spontaneously, of course, but as soon as we are in possession of a few notions of art they multiply rapidly. The answers are quite straightforward, and a dozen paintings can serve as a guide to the basic rules and enrich our appreciation of painting in all its diversity.

This has been the guiding principle in the conception of this book, which is laid out as follows:
The opening pages have been devoted to the history of the museum itself.
This is followed by an introduction to the 19th century, a period of great cultural and social upheaval.
After that the twelve selected paintings are presented in four chapters in which the subject, the painting techniques, and the influences that may have affected the artist are analyzed in detail.
At the end of the book a series of annexes provides some indispensable information:
— a comparative chronology of the main artistic, political and social events,
— biographical notes on each of the painters,
— a glossary of the principal technical terms.

5

Contents

Central gallery, group
of sculptures.
Left: **Julien-
Hippolyte Moulin**
(1832-1884). *The
Discovery at Pompeii*
(1863).
Bronze: 1,87 m.
Right: **Alexandre
Falguière** (1831-
1900). *The Winner
of the cock-fight*
(1864?).
Bronze: 1,74 m. ▶

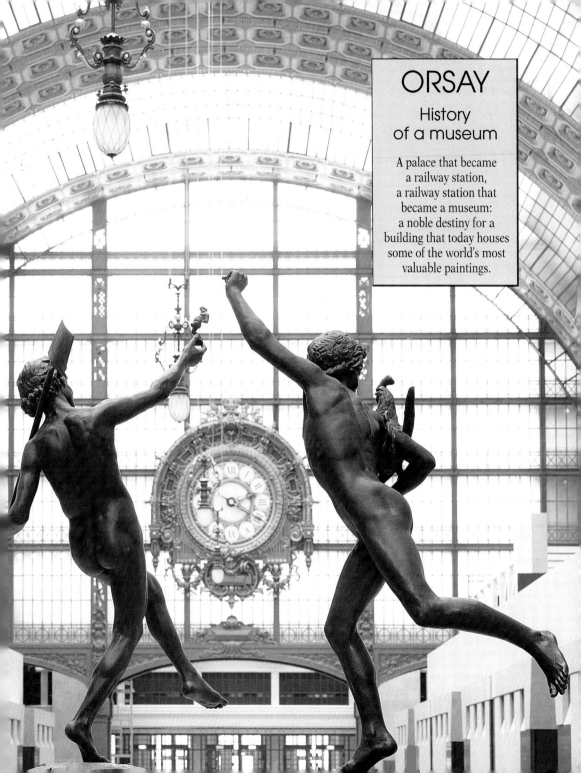

ORSAY

History
of a museum

A palace that became
a railway station,
a railway station that
became a museum:
a noble destiny for a
building that today houses
some of the world's most
valuable paintings.

▲
Victor Laloux (1850-1937)
drawn by Étienne Royer.
Laloux, architect of the Orléans railway
station, had already designed the one
in Tours.

Ever since the mid 1970s, the 19th century has been under constant reappraisal, for we are now far enough removed to properly understand our immediate ancestors. The establishing of Democracy, the rise of natural sciences, the break with the art of the past — all that took place in the last century, and our century is the continuation of it. The Louvre was already too small to house the treasures of preceding centuries, and the Impressionists, for instance, had to be exhibited at the Jeu de Paume. Where could one find a building that would hold not just painting and sculpture, but also architectural models and drawings, the decorative arts of the period (furniture, objets d'art, etc.), and examples of the major technical and cultural developments of the 19th century: photography, cinema, illustrated books, posters? The space would have to be vast, and, if possible, in the centre of Paris…

Coincidentally, the Orsay railway station had just been declared a national monument. But merely preserving the building was not enough: what could it be used for? It had become too short for modern trains and from 1937 only suburban services had run from it. The hotel that had been built to serve the station, luxurious even for its time, needed extensive modernising to be able to continue and was closed in 1973. Yet the building was superb, with painted ceilings, stucco, and rich gilding. It had hosted the fabulous receptions of the Third Republic and the historic press conference of 19 May 1968, at which General de Gaulle announced his return as President of France.

During its slow evolution from a useless but preserved

The Orléans railway station,
Quai d'Orsay
Photograph.
The building of the station was contracted in 1898 and completed in time for the 1900 Universal Exposition. It stands on the site of the Orsay Palace, seat of the National Audit Office and the Council of State, which had been burned down by the revolutionaries in 1871, during the Paris Commune. The station was generally called Gare d'Orsay. ▼

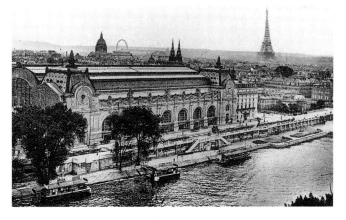

The nave
Photograph. ▶

A number of industrial buildings of the 19th and 20th centuries are being preserved in our time. Left behind by the advances in technology, they nevertheless deserve to be looked at with the same interest shown a palace or a church: they are reminders of our history, and therefore monuments.

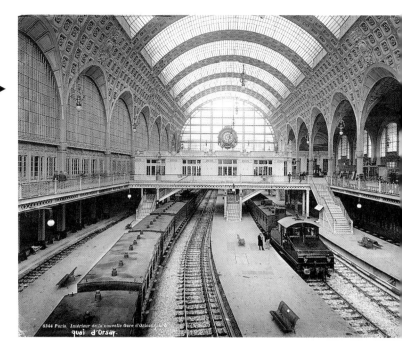

station into that indispensable but elusive museum everybody was searching for, Orsay remained alive: throughout the 1960s it was used as a location for films, and from 1974 to 1980 the Renaud-Barrault theatre company performed in a circus tent erected underneath the arches. They were joined by the art auctioneers, Drouot, who held their sales there from 1976 to 1980, during the renovation of their auction rooms.

Built in 1900 by Victor Laloux, the station is very representative of the official architecture of the 19th century: the modernism of the metallic structure, constructed by engineers, is hidden by a noble stone facade decorated with allegorical carvings.

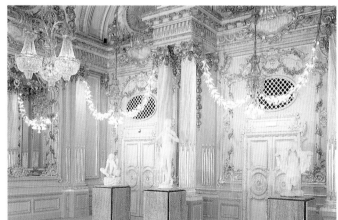

▲
The hotel ballroom
Photograph.

Marble, stucco, and elaborate gilding mask the modernization of the reception rooms: the tastes of the past overlaying the technology of the future!

The ceiling was painted by Pierre Fritel (1853-1942), a conventional painter if ever there was one. The ballroom now houses sculptural exhibits.

11

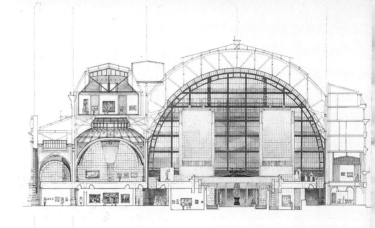

The painter Édouard Detaille joked in his diary on 22 May 1900: "The station is superb and looks like a palace of the arts, while the real *Palais des Beaux-Arts* looks like a station, I suggest Laloux make the exchange if there is still time!" President Valéry Giscard d'Estaing fulfilled this wish in 1977.

The choice of the architects to transform it into a museum (Colboc, Bardon and Philippon), the detailed planning and organisation of a complete schedule took time: the actual alterations did not begin until the summer of 1983, and were to provide employment for more than a thousand workmen for over three years.

The design of the interior was entrusted to the Italian architect Gae Aulenti. Meanwhile, the curators of the museum were busy cataloguing and researching the works of art to go in it. They also decided on the "hanging" of the works in the various galleries of the museum, which finally opened its doors on 9 December 1986.

▲

Orsay Museum, sections of the interior design (above, vertical section of the façade on Place Bellechasse; below, longitudinal section).

The interior was designed by Italian architect Gae Aulenti: she took up the challenge of preserving the unusual space and proportions of the original while also providing exhibition areas, offices, archives, libraries, store rooms and restaurants — not to mention the furniture! The shapes and colours were carefully chosen so as not to clash with the works of art...

▼

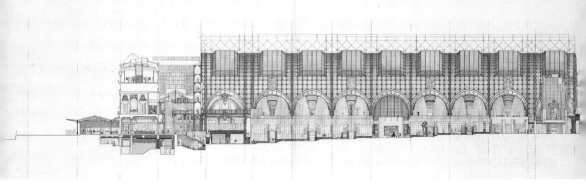

The nave ▶
Photograph.

The open centre of the museum allows the visitor to admire the full impact of the nine soaring glassed-in metal arches. Buildings within a building, the small structures on either side house paintings, and their upper stories lead to further exhibition rooms outside the nave.

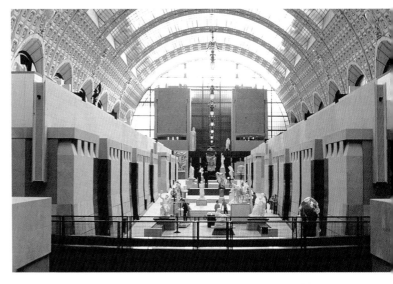

The roof of Orsay station ▶
Photograph.

The roof was decorated with statues, which enhanced the grandeur of the building. The statues represent the three main towns served by the Paris-Orléans railway company.
Nantes was sculpted by Jean-Antoine Injalbert (1845-1933), Toulouse by Laurent-Honoré Marqueste (1848-1920), and Bordeaux by Jean-Baptiste Hugues (1849-1930).

Orsay in numbers

The Musée d'Orsay has a surface of 45 000 m² of which approximately 16 000 m² is consecrated to the permanent exhibition with another 1 200 m² for temporary exhibitions. The museum houses 25 985 works including 3 360 paintings, 205 pastels, 1 170 sculptures, 4 800 items connected with architecture, 1 100 objets d'art, 15 000 photographs and 350 documentary artefacts. In the first three years 11,5 millions people visited the museum. 700 people are employed there of whom about half are security personnel. Every year the museum organizes 12 thematic exhibitions, 2 major temporary art exhibitions, 2 festivals of early cinema, and numerous concerts, conferences, symposiums and debates.

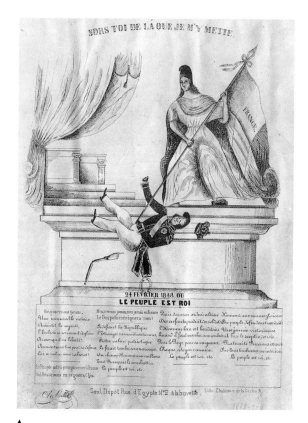

Le Peuple est Roi
Engraving.

This small poster
depicts the French
Republic
overthrowing King
Louis-Philippe on 24
February, during the
revolution of 1848;
below them are the
words of a popular
revolutionary song.

Fernand Cormon ▶
(1845-1924).
A Forge (1894).
Oils on canvas:
70 x 90 cm.

Industry was rising
meteorically, but few
artists made it the
subject of their
paintings.

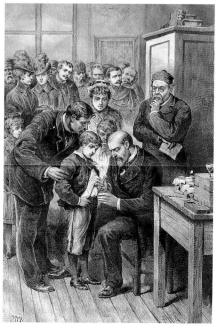

*The Vaccination
against Rabies* (1886).
Drawing by Meyer
engraved by Méaulle.

Seated, Louis Pasteur
(1822-1895): a chemist
and later a biochemist,
he discovered
microbes and
developed vaccination;
in particular the
vaccination against
rabies.

An introduction to the 19th century

The 19th century was a century of change, a time of turmoil and violent breaks with the past in every area: political, scientific, economic, intellectual and, of course, artistic.

The French Revolution took place in 1789, but the Republic did not properly come into being until 1878. Between those two dates, France saw the reigns of two emperors, three kings, a very short-lived republic, and three revolutions!

This instability explains the passionate upheavals that came fast one upon the other during that century. People thought, created, and lived in the midst of epidemics, popular uprisings, and contradictory political regimes. The entire population felt concerned by everything that was taking place, including in the world of art — every novel, every painting signified a deeply felt choice about life in general.

In the midst of this agitation, industry continued to grow, fueled by rapid scientific and technical progress. At the great Universal Expositions, the whole world saw and participated in the new developments. These ranged from trains to works of art, from the modern layout of factories to the invention of electricity.

This also explains the rise of the bourgeoisie, a class that believed in business and enterprise and that was soon to become all-powerful. Whether it be bankers, shopkeepers, doctors, speculators, or civil servants, all of them gambled on the acceleration of the world; they believed in progress but they were above all eager for gain. The *ancien régime* had been a rigid class society in which people lived, regardless of their individual qualities, within the class into which they were born. In the 19th century, people from all levels of society began to take enormous risks to achieve power, to hold on to it, and to make money.

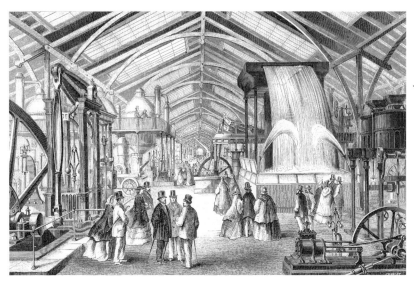

◄ *The 1867 Universal Exposition, the machinery pavilion.* Engraving.

Designed to stimulate and display the progresses made in industry and the arts, Universal Expositions in Paris multiplied from 1855.

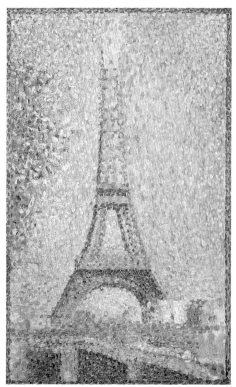

◄ **Georges Seurat** (1859-1891). *The Eiffel Tower* (1888-9). Oils on wood: 24 x 15 cm.

The Eiffel tower was built for the 1900 Universal Exposition. It unleashed violent reactions and became the emblem of Paris.

▲ *A photographer's studio.* Photograph.

Photography was invented in 1839, and immediately became popular despite the cumbersome and expensive equipment.

There were scandals: financial scandals like the affair of the Panama Canal which ruined thousands of small savers; scandals like the corrupt dealing in orders of merit in which even the nephew of a president of France became involved!

Impoverished by the self-seeking of the majority, the workers turned more and more towards Socialist and Communist doctrines. Some, often members of the bourgeoisie, preferred the aggressive methods of the Anarchists: setting off bombs in an attempt to destabilize a society that had become too greedy. The majority of the bourgeoisie, however, remained extremely conservative and protective of its privileges. Nevertheless, at a time when schooling was not obligatory, it was only among this class that new ideas were born, particularly among the artists and their supporters, the critics and collectors.

The world of art was changing too. Up to the 1870s, it was dominated by the Academy, which had retained virtually the same powers that it received on its foundation in the 17th century. It controlled the admission and teaching methods at the Paris school of art (École des Beaux-Arts), as well as the committee that selected works for the annual Salon. This huge national exhibition was the only place for artists to display their works, make sales, and receive prizes and commissions from the state or collectors.

Under the *ancien régime*, there were comparatively few artists. The Academy acted as a go-between for them with the King, the aristocracy and the rich bourgeoisie. Then came the democratisation of society in the 19th century, and the number of artists increased dramatically. In order to protect the privileges of a few of their number, the Academy became more and more conservative in its choices and tyrannical in its judgements. Thus a new phenomenon arose: the avant-garde.

The avant-garde, which is French for "vanguard", was made up of the most innovative artists of any given moment, all of whom were in open conflict with the "rear-guard" of the Academy — the scandals and battles that took place fully justified this military terminology!

The avant-garde took full advantage of the technical advances of the period: the invention of paint in tubes enabled painters to leave their studios and work in the open air; the invention of photography freed them from their traditional mission of faithful reproduction.

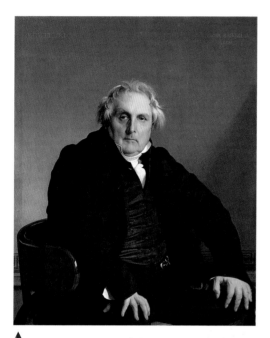

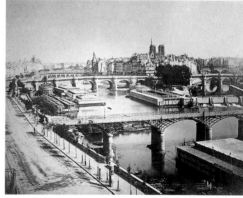

Gustave Legray (1820-1882). *Panoramic view of Paris* (c. 1858). Print on albuminized paper from a glass negative: 40 x 51 cm.

Two 19th century prefects of Paris, Rambuteau and Haussman, radically altered the appearance of the city with their re-planning.
▼

▲

Dominique Ingres (1780-1867). *Monsieur Bertin* (1832). Oils on canvas: 116 x 95 cm.

Louis-François Bertin (1766-1841) was the founder of the *Journal des Débats*, one of the most important political journals of the increasingly powerful press of the 19th century.

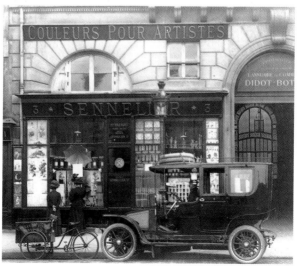

◄ *Sennelier.* Photograph.

Established in 1773, Sennelier is still in business on the Left Bank, close to the École des Beaux-Arts. It was one of the most celebrated artist's materials shop.

Above all it was the way they looked at the world that altered: this was translated into the subjects of their paintings, and into the way in which they painted them. Lastly, because they were rejected by the academic system, the artists needed to find some form of replacement for it, for an artist must sell his work if he is to buy paints and canvas, eat, and have a roof over his head!

Widely attacked by the establishment, artists were championed by the critics and by writers and poets who became closely involved with the painters themselves. Their writings were effective, because the public had come to rely upon the press for information and opinion in a society that was increasingly subdivided and specialized and in which it was no longer possible to know about everything directly.

Rejected by the Salon, the artists began to show their works at art dealer's establishments, which in turn began to multiply and specialize, instead of selling paintings alongside fabrics, as they had done in the 17th century. They metamorphosed into art galleries, and acquired patrons who trusted them.

Not all collectors were rich, but they deeply appreciated art: it was not uncommon for them to leave their collections to a museum at their death. The part they played from 1830 right up to 1970 is predominant: tied to the Academy, the State purchased little and badly; it is mainly thanks to the bequests of collectors that our museums possess works of value today.

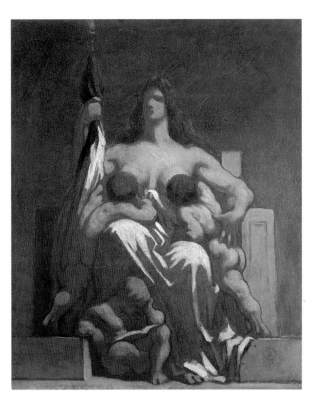

◀ **Honoré Daumier**
(1808-1879).
*The Republic nourishes
its children and
educates them* (1848).
Oils on canvas:
73 x 60 cm.

An allegory is the
personification of an
abstract idea.

**Pierre Puvis
de Chavannes**
(1824-1898).
The Poor Fisherman
(1881).
Oils on canvas:
155 x 192 cm.
A secular subject
treated in a religious
style: this painting was
much admired.
▼

◀ **Jean-Baptiste
Carpeaux**
(1827-1875).
*The Berezowski
bombing
(June 6, 1867).*
Oils on canvas:
130 x 195 cm.

A dramatic style and
a medium size for
a purely current
affairs subject.

A free choice
of subject

One of the first major battles fought by the artists of the 19th century was over their freedom to choose their subject.
Did this mean that painters were not allowed to choose their own subjects? They were, but their subject had to fit into a "genre" for which there were predetermined canvas sizes and prices. In the 17th century, the Academy had classified these genres according to their philosophical importance: a landscape or a still life which only contained objects was considered less important than portraits or subjects that showed human beings. The highest classification comprised history, religion, and themes drawn from literature, because such subjects illustrated mankind's highest aspirations. The largest sizes and the highest prices were reserved for this last category.

The committee selecting work for the annual Salon assessed more than just the quality of the painting; it judged the nobleness of the subject, and decided whether it was respectable. This rigid classification, which was appropriate for the stable and very hierarchical world of the *ancien régime*, was considered totally absurd by the artists of the 19th-century avant-garde.
They chose to exhibit everything that was once considered inferior, such as events in the news or daily life, indifferently portraying the glittering lifestyle of the powerful or the inglorious life of the humble and poor. Added to this, there was a mine of picturesque subjects from faraway places, revealed by the great military and scientific expeditions of the period, to tempt the painters. The right to choose a subject was achieved in various ways. An ordinary subject, for example, could be enhanced by using a large canvas, while a historical or reli-gious subject was made more approachable by painting it on a small one. An-other example is the treatment of secular subjects as if they were religious ones: a group of peasants eating a meal round a table could be made to remind the 19th-century spectator of Christ's Last Supper with the Apostles.

21

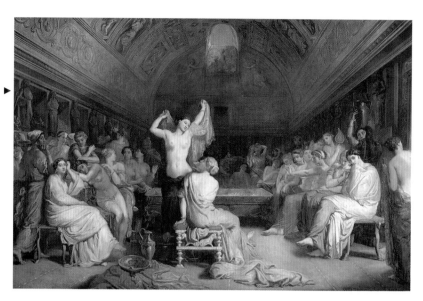

Théodore Chassériau ▶
(1819-1856).
The Tepidarium
(1853).
Oils on canvas:
171 x 258 cm.

A Classical subject,
that of the room in
which Pompeian
women dried
themselves after
the bath.

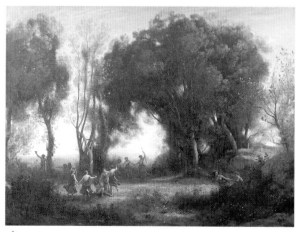

▲
Jean-Baptiste Corot
(1796-1875).
*A morning. Dance
of the Nymphs* (1850).
Oils on canvas:
98 x 131 cm.

The combination
of a landscape with
the mythological
theme of nymphs.

Odilon Redon ▶
(1840-1916).
The Buddha (c. 1905).
Pastel: 90 x 73 cm.

A subject borrowed
from Oriental religion,
suggesting inner life.

Generally speaking, the painters wanted their paintings to have a meaning beyond their ostensible subject and the public itself often judged a painting in the light of its political or philosophical opinions. The artists suggested a certain way of looking at the world, a world that was in a state of constant flux throughout a century confronted with the difficulties of constituting a democratic society and assimilating new scientific discoveries. For example, when the Symbolists painted dreams, nightmares or the great myths of humanity, they were not very far removed from a certain Viennese doctor, Sigmund Freud, who discovered the unconscious and began to analyse its mechanisms during the same period.

By the end of the 19th century, the freedom of choice of a subject was an accomplished fact. Emancipated from the rigid framework of the Academy, artists were able to paint whatever they liked. But what did they like? In an interesting about-turn, they began to choose subjects that would best serve to show off their new interests and still-lifes and landscapes, once considered minor genres, would become predominant.

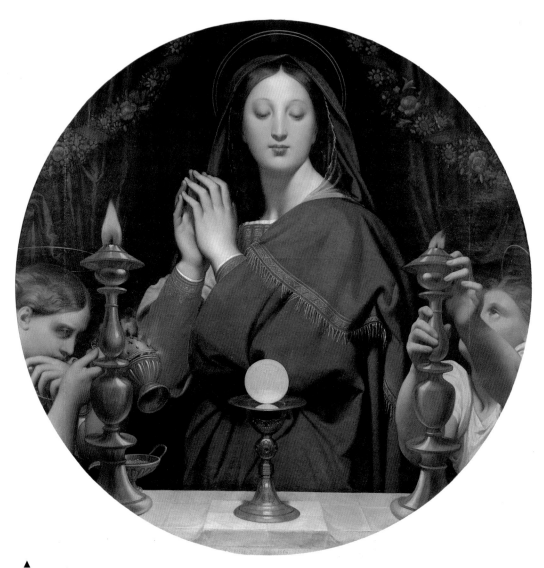

▲

Jean-Auguste-Dominique Ingres, French painter (1780-1867). *Virgin with a Host* (1854). Oils on canvas: diameter: 1,13 metres.

In 1851, Ingres was commissioned, for 20 000 francs, to paint "a painting for which you must submit the subject and a sketch for approval by the Minister." Ingres

submitted the *Virgin with a Host* and a *Joan of Arc* which were both accepted, and completed them in 1854.

At the time, Ingres' public preferred his portraits, or else paintings such as *The Spring*, of a nude carrying an amphora, which was sold for 25 000 francs.

INGRES

and traditional subjects

A classical smooth, religious painting, the Virgin with a Host, appears to be very far removed from our time. And yet the subduedness is misleading.

Framed by two angels, the Virgin, with joined hands, is in prayer before the Host that represents Christ. The subject is a conventional one, it belonged to the highest classification which included religious and historical subjects.

Throughout the 19th century, artists were less and less interested in religious painting. The State, on the other hand, was still very much attached to it, because of its liking for tradition. Thus this painting was commissioned from a recognized master, Ingres, in 1851.

a false conformist

The fact that he was of an advanced age and very famous did not prevent Ingres from being innovative. The painting is not as classical as it appears at first sight, especially for the modern viewer. We have become unused to this kind of subject and this way of painting. Is it the smoothness of Ingres' touch that is so original? No, for tradition insisted that one should not see the brush-strokes, in order to enable the viewer to better "enter into" the painting. But can one really enter into this scene? Is it so very "realistic?" Aren't the colours a little strange? In fact, Ingres concentrated on two aspects of painting that were to become very important for the artists of the second half of the 19th century: he compressed space and treated the subjects in blocks of colour that are almost flat.

The treatment
This describes the way a painting is "done", the manner in which the paint is applied to the canvas.

25

Ingres and the smooth surface

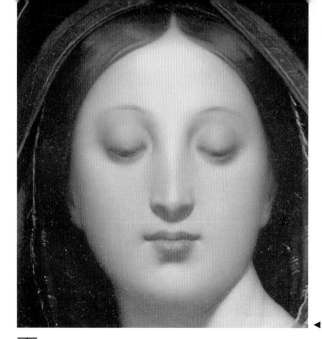

Virgin with a Host, detail.

The brush-strokes are invisible, the colour is almost uniform in that the shadows are indicated the minimum necessary to provide volume. ◄

T he *Virgin with a Host* appears very cold at first glance. Did Ingres intend her to be so? Yes, because this coldness comes from his choice of lighting and colour.

Where does the light come from in the painting? If one looks at the shadows, one perceives that the light comes diffusedly from above. It is a cold, wintry light: artists' studios always face North because the north light affects colour the least and it was precisely colour that interested Ingres.

Invisible brush-work
Many artists used invisible brush-work to give a greater illusion of reality to a painting, as if it were a photograph.

Even if one looks at an enlarged detail of the *Virgin with a Host,* one still cannot see a single brush-stroke: Ingres mixed his colours exactly as he wanted them to be on his palette, and then applied them as smoothly as possible. By using a cold light and little shadow, he produced "blocks" of unified colour. The pieces of gold plate, the cloth, the Virgin's clothes and even her face are all different areas of colour that are almost flat despite the obligatory use of volume. These "colour-zones" appear to have been "lined-up" on the canvas.

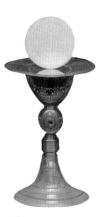

▲
Virgin with a Host, detail.

The Host is placed on an ostensory.

Let us compare this detail with one from a painting by Delacroix. Delacroix applied a multitude of different

Eugène Delacroix
*A Mulattress,
Aline* (1824/26),
detail.
Oils on canvas:
80 x 65 cm.

Delacroix called this
blending of brush-
strokes "stippling."
The colour was built
up on the canvas, and
not mixed on the
palette beforehand,
◄ as it was with Ingres.

▲
**Pyramidal
composition**
Generally used to
make the main subject
come forward and to
increase the
perspective of the
painting, it is used
here to "compress
the whole."

colours directly onto the canvas that, when looked at
from a proper distance, give the overall colour of the
object. Throughout the 19th century Ingres and Dela-
croix were treated as opposites, whereas the art of the
end of the century was to prove that both their ways of
treating colour were valid. It was simply that Delacroix
achieved his results through his brush-work, whereas
Ingres achieved his by his treatment of the surface in
uniform areas of colour.

False opposites
Delacroix had the
reputation of being
a fiery genius where
Ingres was thought to
be "old-hat": in fact
they both shared the
same obsession with
colour.

no breathing space

The way Ingres placed colour on the canvas meant that
every object had an equal value: The Virgin is no "warm-
er", no more "alive", than one of the pieces of plate!

So that this should not disturb the viewer, Ingres used
a very tight composition: one can only see a small part
of the table and, just behind the Virgin, the eye is halt-
ed by a curtain half-drawn over an opaque shadow. In
the same way, the Virgin, the utensils and the angels
are compressed into a narrow area: the lack of a breath-
ing space between the objects accentuates the zones of
compartmentalized colours.

27

Ingres and the end of religious painting

Ingres
Sophie Dubreuil
(1828).
Drawing:
19,2 x 13,2 cm.

Line is predominant in a drawing in the same way colour is in a
◄ painting.

Virgin with a Host, detail, an angel.

The shadows indicate where the light is coming from.

V*irgin with a Host* is a religious painting and we are no longer used to seeing this kind of subject outside museums and churches. But let us try to imagine that we are living in the 19th century...

Ingres used a cold light that "saturated" the tints and produced few shadows; he tightened the composition to achieve a *cloisonné* effect, thereby enhancing the importance of each colour, which was treated as an almost unbroken surface. It could be said that he somewhat distanced himself from the subject itself, because he was more interested in how he was painting than in what he was painting. But this results in a feeling of unease, as if the scene he painted were completely artificial. Was the public aware of this? It is hard to say. What is certain is that Ingres was considered the greatest painter of his day.

imitated by the "Pompiers"

Ingres was therefore much imitated, especially since he also taught, and had over two hundred pupils in his lifetime. But his followers never really understood what he was doing. They believed that the pyramidal compositions and the invisible touch were a submission to the ancient rules of art. In their own paintings

The "Pompiers"
Pompier is French for fireman. Because of the resemblance of the helmets of armed heroes in academic mythological paintings to firemen's helmets, the Romantic artists used the word to mock any art that is pretentious and insipid, which perfectly describes the sentimental conformism of Ingres' followers.

they warmed up the colours and deepened the shadows to give them "atmosphere", with the result that they produced illusionist paintings of no interest at all.

a religious painting

Ingres
Ingres in his studio
(1812), detail.
Pen and watercolour:
◀ 46,6 x 56,6 cm.

Does the *Virgin with a Host* give an impression of solemnity? Yes, indeed it does, thanks to the traditional composition that brings the Virgin and the Host to the forefront. Does she give an impression of piety? Yes, because her hands are joined in prayer and her expression is both sweet and serious. But the angels are much less attentive and respectful: they look as though they were playing rather than adoring the host. This cheerful note in such a serious subject satisfied the 19th century viewer because the Catholic religion was going through a crisis at the time, and it was necessary to make it appear friendly, mundane and familiar. This is one of the reasons why so many of the paintings of the time show religious scenes "disguised" as everyday ones, like *The Day's End* by Cazin.

The Providential State
By the middle of the 19th century, the State had become the only purchaser of religious paintings.

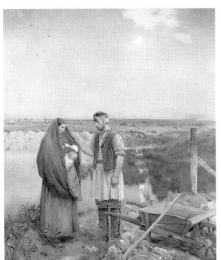

◀ **Jean-Charles Cazin**
The Day's End (1888).
Oils on canvas:
1,99 x 1,66 m.

This peasant couple and their child resemble the Holy Family (Mary, Joseph and Jesus).

Édouard Vuillard
The Chapel of the Palace of Versailles
(1917/18, re-worked in 1928).
Paper mounted on canvas: 96 x 66 cm.

Despite the subject matter, this is by no means a work of piety. ▶

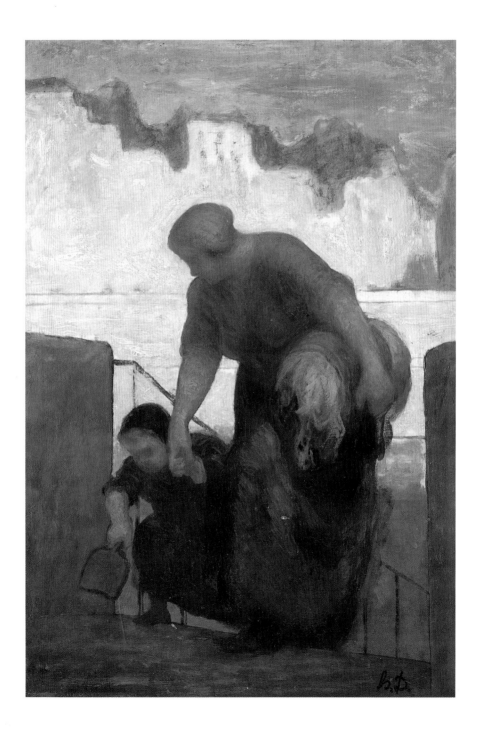

DAUMIER

and current events subjects

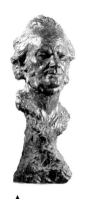

▲
Honoré Daumier
sculpted by himself.
Bronze.

The Washerwoman is an everyday scene of the kind that has long been the subject of paintings. Daumier, a convinced Republican, would give it a political message.

A woman is returning from the quay where she has been doing her washing; bent under the weight of her linen, she is supporting the child with her who is carrying the washerwoman's paddle. In the distance one can see the opposite bank of the river with its sun-lit houses and red roofs standing out against the sky. Why is it that this painting still moves us? Washerwomen of this kind are long gone, and yet it seems as though we know this one. This is because Daumier treated the subject very restrainedly. We could simply remember a woman helping her child up some steps. His painting technique plays a major role: the masses are simplified, the brush-strokes are very visible, and the colours are strong without being violent.

A caricaturist painter
Daumier is best known for his caricatures satirizing the manners and politics of his day in newspapers such as *La Caricature* and *Le Charivari*.

a belated painter

Honoré Daumier, French painter and caricaturist (1808-1879). *The Washerwoman* (c. 1863). Oils on canvas: height: 49 cm, width: 33,5 cm.

Daumier took up painting comparatively late, at the age of forty, just as the Second Republic, which he fervently supported, was installed after the revolution of 1848. He learned to paint by watching his friends at work. He was not in search of fame, preferring small canvases to large, "noble" subjects. His aim was to reach his viewer through simplicity. His paintings are informed with a political message because he gave them a universal dimension: this is why *The Washerwoman* is still meaningful today.

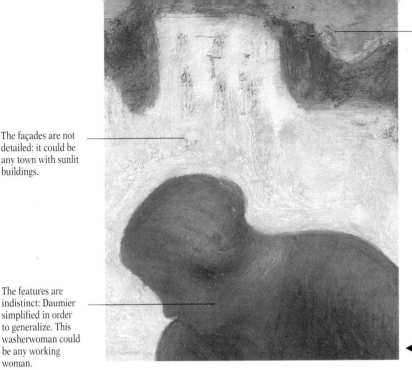

The façades are not detailed: it could be any town with sunlit buildings.

This sky is not very blue, nor does Daumier want to suggest a storm; rather: a muggy, hopeless day.

The features are indistinct: Daumier simplified in order to generalize. This washerwoman could be any working woman.

◄ *The Washerwoman*, detail.

Daumier made his subject stand out

To give a striking actuality to *The Washerwoman*, Daumier treated the subject very audaciously.
The woman and her child are in the foreground, but they are much darker than the rest of the painting. This was in direct contradiction to traditional painting in which the main subject was clearly lit in order to bring it to the forefront. If this is the case, how did Daumier manage to make his figures stand out so vividly?

a daring composition

Let us take a look at how simply the different surfaces are laid out: the buildings on the opposite bank, the river, the woman and her child framed by the railings of the quay are actually very distant from each other. Daumier made no attempt to lead the eye progressively from the foreground to the background of the painting, which he could have done by putting a boat on the river, or having some carriages move along the opposite bank.

Where did this stark treatment of space come from? It came from lithography, which Daumier had practised during his twenty-year career as a caricaturist. In lithography, the artist places his figures and a few characteristics of their setting on a white page; it is up to the viewer to use his imagination to fill in the blanks. A few crossed lines on the ground "make" a pavement, a few vertical ones denote a building, etc. The images are pared down to the minimum in order to make them more striking — this was essential, because Daumier's lithographs were printed in the newspapers and therefore had to be easy to assimilate and immediately recognizable.

In *The Washerwoman* we supply the elements that are not clearly portrayed: the windows of the houses, the busy life of the river, the street, etc. Thus there is nothing to distract us from what is important in the painting itself: a dull cloudy sky, a woman tenderly guiding her child.

Daumier
Robert Macaire the dealer (c. 1836/38), detail.
Engraving from *Le Charivari*.

Macaire is the typical dishonest speculator of the period. A few lines, a lot of "white": the scene is described.
▼

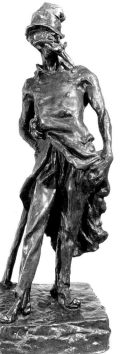

◀ **Daumier**
Ratapoil (c. 1850).
Bronze:
43 cm. high.

Ratapoil was a caricature of Napoleon III which appeared frequently in Daumier's engravings. Daumier made him into a sort of cowardly hero, always on the side of the mighty, but who was actually totally feeble.

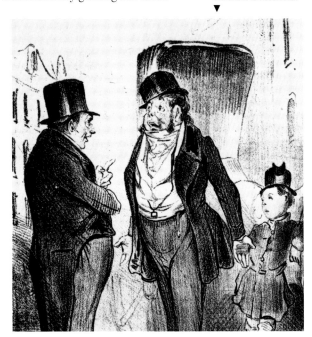

Daumier got to the heart of his subject

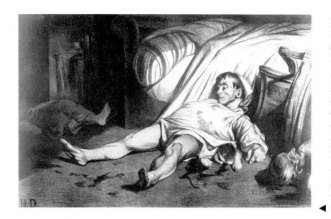

Daumier
The massacre of the rue Transnonain.
Lithograph.

On 15 April 1834, the army massacred all of the inhabitants of a building with the excuse that they might have been hiding revolutionaries. Baudelaire wrote: "This is not exactly a caricature, it is history, it is the terrible and ◄ trivial truth."

Daumier made this 19th-century washerwoman extremely familiar. How did he make us feel sympathy for her? He caught exactly the tender gesture of a mother bending protectively over her child despite the weight of her burden, and the child's efforts to climb the steep steps with its short legs, stretching out its arms to keep its balance. It is these gestures that compensate for the fact that neither the city nor the faces are given any features. One could be in any district of Paris on the banks of the Seine, or in any town on a river. There is no detail: all we are shown is a woman who works hard and loves her child.

the lessons of caricature

The system that Daumier used here is generalization, a striking simplification, the timeless gesture. Once again, this is due to his experience of caricature, in which the main features of a personality are exaggerated in order to make the audience laugh. Daumier was as good at drawing caricatures of famous politicians as he was at creating "types": the typical speculator, the typical doctor, etc. But everything depends on the use an artist makes of this perspicacity. The same techniques can achieve opposite effects, and in this particular instance, they make us sympathise with *The Washerwoman* and her child.

What Daumier brought to this talent was a great knowledge of painting, both of the use of colour and of the

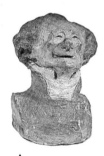

▲
Daumier
Charles Philippon.
Unbaked clay coloured in oils:
16 x 13 cm.

This bust is part of a series called "The Parliamentarians", begun in 1832. Philippon was also a journalist.

34

brush. The dark figures standing out against the light background become almost dramatic. A great economy of colour — just a few clear tones on the bundle of linen — accentuates the contrast with the luminous city. The paint is applied thickly and one can clearly see the brush-work: this gives a great density and a striking relief to the subject. Daumier was the first to use colour this way and the simplicity with which the areas are laid out led many to follow in his footsteps.

◀ Jean-François Millet also wanted to show a generalized reality: this face belonging to one of his *Winnowers* (1857, detail) is hardly visible. It was the overall effect of the painting that was meant to show the hardness of peasant life.

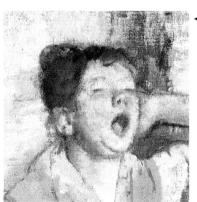

◀ In the same spirit, Degas deformed the face of one of his *Laundresses* with an exhausted yawn (*c.* 1884, detail). he had no intention of making her attractive. Jules Bastien-Lepage, on the contrary, flattered the face of the astonished peasant in his *Harvests* (1877, detail): he inspires us with a pity for the girl that doesn't extend to rural conditions. ▶

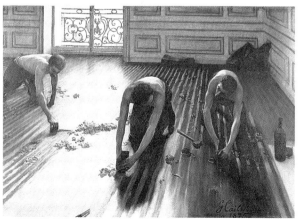

Gustave Caillebotte
The Floor planers
(1875).
Oils on canvas:
192 x 146 cm.

An unromantic painting of workmen at work. No details of faces, but a bottle to ◀ keep them company.

35

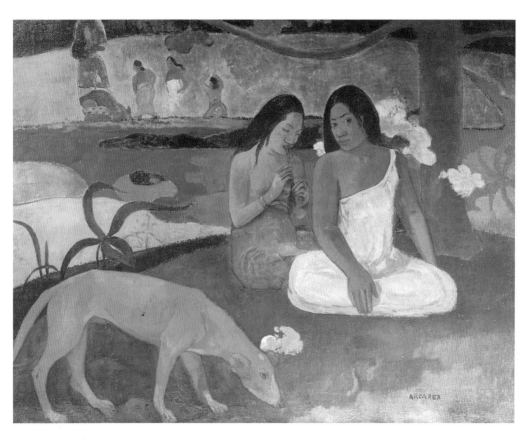

In Tahitian "arearea" means "amusements." Gauguin painted this canvas during his first and probably happiest stay in Tahiti. He complained on reaching Papeete that, "It is Europe, the Europe I thought I had left behind for ever, with every aspect aggravated by colonial snobbery, by a childish and grotesque imitation bordering on caricature. This is not what I came so far to find."

▲
Paul Gauguin, French painter (1848-1903). *Arearea* (1892). Oils on canvas: height: 75 cm, width: 94 cm.

GAUGUIN
and Primitivism

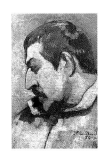

<u>Gauguin is famous for his adventurous life: a member of the stock exchange, he dropped everything at the age of 35 — career, wife and children — for painting! He lived far away from France and had few friends despite the admiration all the artists felt for his work.</u>

The nickname of this painting is the "red dog", because it was the unusual colour of the dog that struck people when this painting was first exhibited in Paris. Indeed, one mostly talks of colour when discussing Gauguin's work. His colours are not utterly impossible, but they are very exaggerated and carried to extremes.

an exotic paradise

Two women sitting under a tree, one of them playing a flute — this appeared very exotic indeed to the French. The exoticism of Gauguin's paintings was not their only original feature: the calm poses and the peaceful landscape suggest a sort of earthly paradise bordering on the religious. The woman in white stares out at us with a look that seems to express her surprise at the agitation of Western civilization.

The field in the background and the areas of vegetation have a nearly uniform colour and a few shadows on their pareos give them volume. This way of treating a composition as a series of almost completely flat planes accentuates the impression of calm. In 1892 this technique was revolutionary.

Gauguin ended his life a very sick man, in a Tahitian house he called "The House of Pleasure." His art expresses the desire for happiness that led him to leave France.

Depth of the background
The simple juxtaposition of coloured areas gives an impression of depth.

37

Gauguin and the power of colour

Like all the late 19th-century artists, Gauguin made no attempt to reproduce reality: he wanted to produce an impression. But how?

In *Arearea*, the two women in the middle ground express serenity. One can also see three people worshipping an idol in the background. Although he did not share them, Gauguin admired the local beliefs, for they seemed to him closer to nature than Western ones.

idols, colours...

There is also an idol in *La Belle Angèle*, painted in 1889, a Peruvian-looking statuette that Gauguin probably saw in a museum but that had nothing at all to do with Brittany, where this painting was done. One realizes therefore that in *Arearea* Gauguin was not trying to depict a religious scene and that the meaning lies elsewhere.

Gauguin and other artists of his time were fascinated by ancient and primitive art, for they were persuaded that these forms of art enable one to reach stronger and purer emotions and thoughts than we are used to.

Oh ye painters in search of the techniques of colour, study carpets!

Gauguin, *circa* 1896

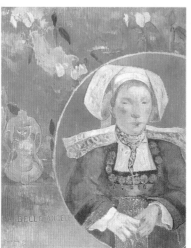

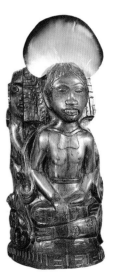

◀ **Gauguin**
La Belle Angèle (1889).
Oils on canvas:
92 x 73 cm.

Mme Sartre, a hotel-keeper at Pont-Aven in Brittany, was perplexed by this strange portrait. Indeed, the medallion, the flowered background and the idol were enough to perplex even an informed public!

▲
Gauguin
Idol with a Shell
(1893).
Wood, mother of pearl halo, insertions of bone for the teeth: 27 cm.

Gauguin made many sculptures and bas-reliefs.

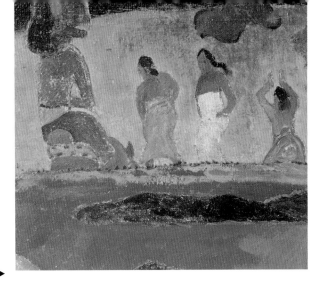

Arearea, detail.

One can clearly see the thinness of the paint and the simplification of the forms. The size of the figures compared to those in the middle ground give an impression of depth. ▶

At the time ethnic museums and colonial exhibitions were being inaugurated all over Paris. Thus Gauguin was able to see primitive objects painted in bright colours and became convinced that colour has immense power over the individual and his emotions.

... and shapes

One notices that the colours in *Arearea* are treated in a very "flat" way: Gauguin dispensed with most of the shadow and was no longer concerned with showing the brush-work or providing the personal touch. Primitive art also showed him the immense power of simple shapes and strong colours. The dog "comes" to the forefront because it is red, the women stand out against a succession of areas of similar colours (yellow, orange, pink), and the green is so bright that it enhances the idol and the figures in the background.

Art is an abstraction. Look for it in nature by dreaming in its surroundings.

Gauguin

There is one striking feature, however, whether it be in *La Belle Angèle* or in *Arearea*, and that is the presence of writing in the painting. Painters generally signed their canvases discreetly, but Gauguin was not content just to sign his work, he gave it a very visible title. When we look at the scene, we see it "in depth", but the writing is there to remind us that it is in fact painted on a surface that is as flat as a piece of writing paper. For Gauguin the strength of a painting no longer depended on its power to create an illusion of reality.

▲
These details from *Arearea* and *Still life: Fête Gloanec* (1888) are examples of very visible titles and signatures; in *La Fête Gloanec* Gauguin even amused himself by using a pseudonym... "Madeleine!"

Gauguin opened up new directions

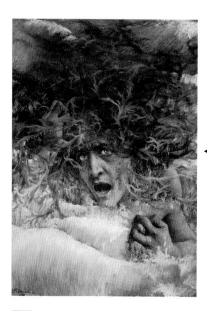

◀ **Lucien Lévy-Dhurmer**
Medusa or *The Angry Wave* (1897).
Pastel and charcoal on cream paper: 59 x 40 cm.

The Symbolists were very fond of pastel because of its extreme fragility and near impalpability.

▲
Odilon Redon
Portrait of Gauguin (1903/05).
Oils on canvas: 66 x 54,5 cm.

In this "portrait" Redon was not trying for a likeness: he "symbolized" the painter through a constellation of iridescent colours.

The end of the century was in effervescence and Gauguin's painting evolved in the midst of a variety of "movements", all of them tending to work on the spectator through the choice of subjects and the use of colour. Not everyone was attracted by the exotic. *Medusa,* for example, was a figure borrowed from Mythology, symbolizing Love and Death. To show her power, the artist depicted her as a wave that carries all before it. This painter belonged to a movement called the Symbolist movement, whose members had one thing in common with Gauguin: they painted subjects that suggested an emotion or a thought. In *Arearea*, the women's pose, the calmness of the painting, suggest the second title of the work: "Amusements." Gauguin said about this painting that he wanted to achieve "harmonies that represent nothing that is real in the usual meaning of the word and that express no direct idea, but that make you think the way music makes you think."

▲
Gauguin
Fare (c. 1891/92).
Pen and pencil, 12 x 8,5 cm.
Tahiti notebook.

40

a flat surface...

Other artists of the period were deeply interested in colour, as is demonstrated by Sérusier's *The Talisman,*

which he painted under the supervision of Gauguin, his elder by 14 years. "How do you see this tree", Gauguin had asked. "Is it really green? Paint it green, then, the most beautiful green on your palette; and this shadow, rather blue? Do not hesitate to paint it as blue as possible." One of Sérusier's friends, Maurice Denis, wrote a phrase in 1890 that was to become famous: "Remember that a painting, before being a battle-horse, a nude woman or some anecdote, is essentially a flat surface with colours assembled in a certain order."

Gauguin's fascination with the simple forms in non-Western art resulted in a major movement: Primitivism. Primitivists would try to find a new way of painting and sculpting through the study of other cultures as, for example, the Cubists did at the beginning of the 20th century, when they collected African art.

Gauguin
Be in Love and You Will be Happy
(c. 1898/99), detail.
Wood engraving.
▼

Paul Sérusier
Landscape at the Bois d'Amour, called *The Talisman* (1888).
Oils on wood:
27 x 22 cm.

In this landscape — painted on the cover of a cigar box — the painter took colour to the very limits of the believable. *The Talisman* would be very important to the "Fauves" at the beginning of the 20th century. ▶

41

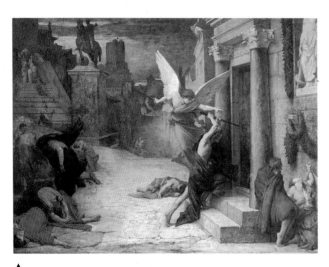

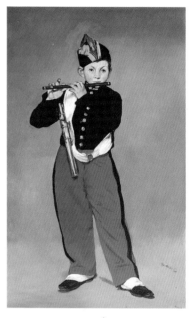

▲
Élie Delaunay
(1828-1891).
The Plague in Rome
(1869).
Oils on canvas:
131 x 176 cm.

A strict linear
perspective, using light
to accentuate the
dramatic atmosphere.

**James McNeill
Whistler** (1834-1903). ▶
*Portrait of the Artist's
Mother* (1871).
Oils on canvas:
144 x 162 cm.

A narrow range
of colours construct
the space in this
*Arrangement in grey
and black*.

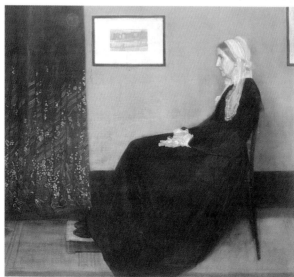

▲
Édouard Manet
(1832-1883).
The Fifer (1866).
Oils on canvas:
161 x 97 cm.

Manet was an avant-
garde artist. Here he
dispensed with a
setting and applied
the paint as flatly as
possible: the form is
entirely achieved by
the use of colour. One
critic accused him of
having painted "a
playing-card figure!"

The conquest of space

A painting usually tells a story, even landscapes and still lifes are anecdotal, suggesting the shortness of life, the smallness of man, etc. It portrays people in the street or in the countryside, or else objects laid out on a table, etc. But how should this space be treated?

In perspective? That appears obvious today because photography, cinema and television have accustomed us to this kind of space. As a matter of fact these techniques were developed in accordance with the optic and geometric laws of perspective used in painting. But these laws haven't always been known. They were discovered in Italy in the 15th century, at the beginning of the Renaissance. Before that, during the Middle Ages, or in other countries such as Egypt, artists painted pictures without perspective, and everybody found that method of representing reality perfectly acceptable.

European painters used perspective systematically from the 15th century right up to the middle of the 19th, when they ceased to find it "realistic." Beginning with the Impressionists, artists felt that it was wrong to construct space from a single fixed view-point, one motionless eye did not really correspond to reality, for people have two eyes which are in constant movement. Added to which, the world does not "pose" for an artist, nor is it motionless. This analysis led to the theory that a painting should not be a mere reproduction of a fixed reality, but rather the result of an impression, an interpretation of a scene by an individual artist according to his view of the world.

So what needed to be done? It so happened that photography was there for those who clung to the traditional treatment of space and objects. The invention and rapid development of this new medium dispensed artists

Pierre-Auguste Renoir
(1841-1919).
The Swing (1876).
Oils on canvas:
92 x 73 cm.

A fluttering touch
for a colourful
"impression." ▶

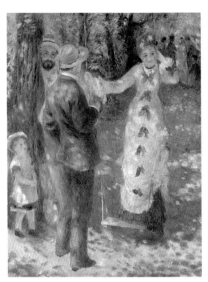

Alfred Sisley
(1839-1899).
Snow scene at Louveciennes (1878).
Oils on canvas:
61 x 50 cm.
▼

The exaggerated depth
of the path is
contradicted by the
very visible thickness
of his touch.

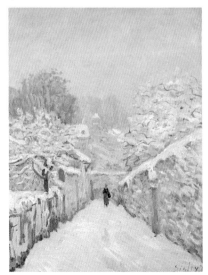

▲
Odilon Redon
(1840-1916).
The Chariot of Phaëton
(1905/14).
Pastels: 91 x 77 cm.

Pearlized colours for an
infinite space: the sky.

from having to obey pictorial laws that they no longer found relevant —
especially since they had begun to study the art of earlier periods and other
civilizations. Primitive art and Oriental prints showed them different ways
in which reality could be treated.

All of this resulted in a search for new ways of representing space, and
the artists were to find these in the constituent parts of the painting itself.
They discovered that the illusion of depth could also be achieved by the
juxtaposition of certain colours, by different kinds of brush-strokes, and by
breaking up the surface of the canvas itself.

The geometry used in linear perspective is a "tool" that was outside paint-
ing proper. From the 1860s, artists abandoned such tools in favour of the
methodical development of the various parts of the painting itself.

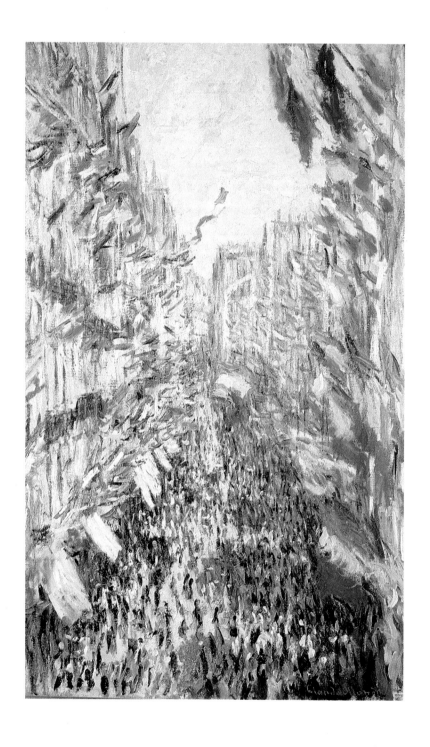

MONET

and a world in movement

Monet once said that he would have liked to have been born blind and to have suddenly regained his sight. He could then have painted what he saw without any pre-conceptions, experiencing in this way the purest impression possible.

A bright summer's day, a street decked with flags and filled with the crowds of a working-class district on holiday. The atmosphere is noisy and gay, France had been a republic for seven years, and in this painting, Monet makes us experience all those jumbled sensations.

red, white, and blue

Nothing is truly "described", however. The brush-strokes are too large to give a minutely detailed picture. This being so, what frame of reference does the painting provide? The colours, of course, since red, white, and blue are the colours of the French flag. What else is there? The patch of blue at the top of the canvas can only be the sky, and then there is the composition. The painting is constructed as two triangles that meet in the middle, giving an impression of depth.

Is this sufficient? Certainly, for a painting does not have to be a faithful reproduction. Monet believed that the object of a painting was to transmit an artist's impression to the spectator. There was a whole group of artists who felt as he did, but their work was rejected so systematically by the Salon that they decided to hold their own exhibition, in the shop belonging to the photographer Nadar. This was in 1874, and it was the first Impressionist exhibition.

◀ **Claude Monet**,
French painter
(1840-1926).
*Rue Montorgueil.
Fête of 30 June 1878*
(1878).
Oils on canvas:
hcight: 80 cm,
width: 90 cm.

At Nadar's shop
The exhibition
included many
landscapes so, to avoid
monotony in their
titles, Monet asked for
the word *"Impression"*
to be added to his
Sunrise. The word was
taken up as a joke by a
journalist from *Le
Charivari* called Leroy:
the "Impressionists"
had been christened!

47

Monet built space using light

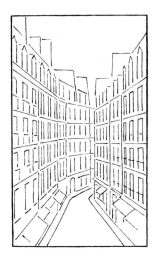

Monet flattened perspective
The drawing on the left is in the correct perspective, the one on the right shows how Monet accentuated the reduction in size and "flattened" the depth of the painting. ◀

Like all of the Impressionists, Monet painted from life, in the open air. It was the constantly changing natural light that led him to question the validity of traditional perspective. Where does the light come from in *Rue Montorgueil*? From the sky, naturally. The pavements are a little darker than the rest of the painting, but overall the light plays on the pale fronts of the buildings, on the flags waving in the wind, on the clothes of the passers-by and on the surface of the street itself.

a landscape in movement

Up to the mid-19th century, artists worked in their studios and used linear perspective to construct space. They also used a directed light-source, providing dark shadows and strong contrasts that accentuated the dramatic effect of a subject. Conventional painting methods gave the illusion of a window opening onto a motionless world, whereas, by setting up his easel in the open air, Monet discovered that light is in fact being altered constantly by clouds, by the time of day or by the seasons. Objects are also more or less shiny, or more or less colourful and people, of course, are in constant movement. Everything is changing before our eyes, and therefore Monet believed that a painter could only catch a fleeting impression of a given subject.

▲
Monet (right) and Clemenceau, the President of France, in Monet's property at Giverny.

This could entail the artist having to work fast to capture that fleeting moment, and this was the case with *Rue Montorgueil*, in which the stippled brush-strokes denote speed. In other works, Monet took his time to reconstitute his impressions, as in his series of paintings of stations and cathedrals, in which he blended his brush-strokes.

That said, the spectator still has to be able to find some concrete points of reference : how did Monet go about making the scene "recognizable?" He did so by playing on our habitual acceptance of traditional perspective. He placed us in the middle of the Rue Montorgueil,

▲
Monet
Rouen Cathedral: harmony in blue and gold, full sunlight (1893).
Oils on canvas: 107 x 73 cm.

In 1892 and 1893, Monet produced a series of four paintings of this cathedral in different seasons and at different times of day.

Monet
Gare Saint-Lazare (1877).
Oils on canvas: 75 x 104 cm.

As he had done in *Rue Montorgueil*, Monet exaggerated the conventions of traditional space: the station is seen from the front and the lines of the structure lead
◄ the eye.

and led our eye along the line of buildings. Even so, the diminishing size of the buildings is very exaggerated in relation to the laws of linear perspective, and if we do in fact follow these deceptive vanishing lines, it is because we are in reality being led along them by the colours. For example, the three colours of the flags are never exactly the same from flag to flag. At times the white has a yellowish tinge, or the reds are quite dark, or again the blues are washed out. Used in this way, the colours "betray" the light and therefore the volume.

49

Monet showed the mobility of the eye

Besides the play of light on an object, Monet also took the mobility of the eye into account. We see *Rue Montorgueil*, but we are not led to concentrate on any one part of it.

What happens if we isolate a detail of the painting? We no longer see what it is supposed to be! To understand what it is depicting, we have to put the detail back in its place on the canvas of which the lower part is the ground and the upper part is the sky. Those vertical strokes highlighted with a few bright touches are the passers-by. The touch is vertical for the crowd, but we notice that it is slanted for the flags and circular for the sky. The direction of the brush-stroke is therefore an important guide to our understanding of the painting.

which style of treatment?

If one does not limit oneself to academic works painted in the false light of the studio, if one approaches immense and ever-changing Nature, light, endlessly varied, becomes the soul of the painting.

In *Rouen Cathedral*, on the other hand, the brush-strokes are smaller and blend together more. Why did Monet use a different treatment? Because, when he painted his series of *Cathedrals*, he worked slowly, but in order to show us something equally as ephemeral as the holiday scene in *Rue Montorgueil* — an instant impression of a specific time of day in a specific season — he painted the light rather than the cathedral itself.

Whether he worked fast or slow, Monet always succeeded in showing the speed at which our eyes take in a scene.

Camille Pissarro
Young girl with a stick
(1881).
Oils on canvas:
81 x 64 cm.

In this work by another Impressionist painter, the touch is dense: the young girl does not stand out from the surrounding greenery.
▼

50 Émile Zola

Rue Montorgueil,
detail: the passers-by.
Rouen Cathedral,
detail: the porch.

Brush-work that is
rapid and impossible
to decipher at times,
"blended" but
◀ iridescent at others.

We only retain an overall impression of the working-class
district on a public holiday or of the sculptured and sun-
lit façade of the cathedral. Our eyes, which are in
constant movement, receive every light stimulus simulta-
neously, regardless of whether its source is close or far
away. In *Rue Montorgueil,* the buildings in the fore-
ground are no "sharper" than those in the background. In
Rouen Cathedral, the details of the carvings are not
shown. We lose the sense of a scene reproduced in depth,
as was the custom in conventional paintings, in which
only objects at a distance were shown out of focus.
Classical painting was governed by linear perspective,
which presents a scene from a single static viewpoint,
like the lens of a camera. This construction of space
served to show the distance between motionless
objects, but for the Impressionists a painting was a
meeting of two moving bodies: that of the world, of
objects and of light, and that of the painter himself.

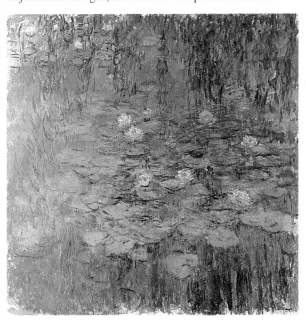

◀ **Monet**
Blue Water-lilies
(after 1917).
Oils on canvas:
2 x 2 m.

Monet's last paintings
were very large — they
disorientated the
public because there
was no horizon line
and the water-lilies are
barely recognizable.
People felt they were
standing before a solid
wall of painting. These
works were later very
much admired by the
abstract painters of
the 20th century. 51

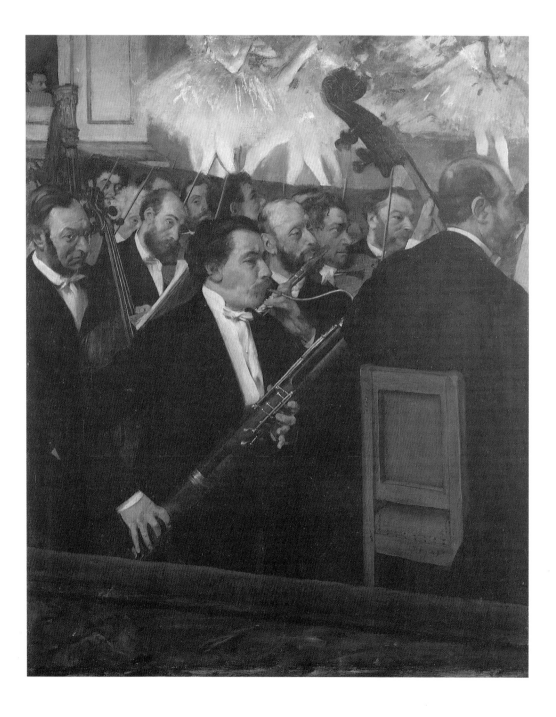

DEGAS

and the mobility of the eye

Degas was a friend of the Impressionists, but he did not paint at all like them. Indeed, he criticised them for being too attached to the real world and its sensations.

Degas was enamoured of the world of theatre and ballet and was the first artist to use it consistently as the subject of his paintings. He showed sides of the theatre that the public did not have access to, or that it paid little attention to, as in *The Orchestra of the Paris Opera*. When the dancers are on stage, the audience does not usually watch the orchestra.

Competition
The portrait began to disappear from painting at the end of the 19th century, because it was replaced by photography.

deceptively conventional

Setting aside the unusual subject, *The Orchestra of the Paris Opera* appears to have been painted in a very conventional way. The touch is invisible and the colours are very restrained. We imagine ourselves seated in the front row, close to the orchestra. Degas amused himself by surrounding his friend, the bassoonist Désiré Dihau, with portraits of other friends who were not musicians!

What lies behind this conventional treatment? A practised eye is needed to see it. If we "re-live" the scene in our imagination, we realize that it would not be physically possible to see both the bassoonist's head and the dancers' legs. And why is the neck of the double-bass so prominent? Contrary to what we might expect, the painting is not composed in accordance with the laws of perspective and Degas leads us astray in an impossibly disjointed space.

Degas
Two studies of dancers, detail.
Drawing.
▼

◀ **Edgar Degas**, French painter (1834-1917). *The Orchestra of the Paris Opera* (1868/69). Oils on canvas: height: 56,5 cm, width: 42,2 cm.

Degas showed his friend, the bassoonist Désiré Dihau, in his professional capacity.

53

Degas followed the eye inch by inch

Degas agreed with the Impressionists that the eye is in constant motion, but he did not reach the same conclusions as they did.

One could say that in *The Orchestra of the Paris Opera*, Degas showed us what a member of the audience might see in a "moment of distraction." He is seated in the front row, he lowers his eyes to the barrier round the orchestra pit, close to his knees, then he looks up at the bassoonist, at the back of the bass-player's stool and at his impressive instrument. Lifting his eyes inch by inch, he looks further and further away. He sees each of the faces distinctly, regardless of the row in which the musician is seated. The painting comes to an abrupt end at the same time as the "moment of distraction", at the instant at which the spectator's eye reaches the legs and tutus of the dancers.

a perceptive eye

The Impressionists held that the eye's movement is so rapid that a painting should not show any details. Degas believed the contrary, he thought that all the objects in a painting should be "sharp" — that even a moment of distraction could be broken down into phases in which the eye sees distinctly.

▲
Degas
The fourteen year-old dancer (1880). Bronze, tulle tutu, satin ribbon in her hair:
98 x 35,2 x 24, 5 cm.

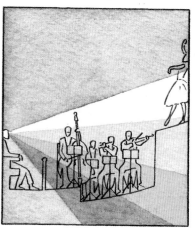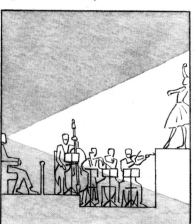

◀ With linear perspective (right), the space depicted in a painting is homogeneous. Degas did the contrary (left), breaking up space according to the movement of the eye. The painting gathers different moments into an assembly of incompatible visual "sections."

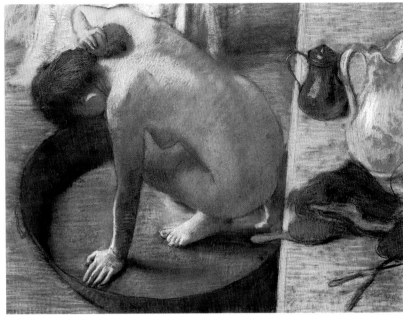

Degas
The Tub (1886).
Pastels on paper:
60 x 83 cm.

"Up to now," Degas
said, "nudes have
always been shown
in poses that imply a
public." He preferred
to show women "seen
through a keyhole",
another form of the
separation between
public and performer. ▶

Degas the pastellist
Degas used pastels,
which are coloured
chalks, very often.
The technique is very
difficult, because it is
impossible to make
corrections.

But if our member of the audience is looking at the
barrier round the orchestra pit, he cannot possibly see
the dancers' legs at the same time because they are
quite simply out of his field of vision!
Is it really possible for him to see the bassoonist in pro-
file when that bassoonist is seated slightly above him?
No, of course not! And yet all these consecutive moments
in time — which are therefore incompressible — are
presented simultaneously in one and the same paint-
ing, in unified sections running upwards from the bot-
tom of the canvas.
One could say that Degas "broke-up" the space in
conventional perspective and then pieced it together
again bearing in mind the time — however short — it
takes to look at something.
Degas employed a number of methods to achieve this.
Here it is done vertically up the canvas, but in *The Tub* it
is done across the canvas. The plane of the table on
which the toilet-set is placed is out of true with the angle
at which those objects are shown, and it is equally incom-
patible with the oval of the tub. Lastly, the horizontal
lines of the pastels emphasize the flattening of the space.

▲
Degas. *Trapezist*.
Drawing, sketch-
book, fol. 14.
Study for *Miss Lala at
the Cirque Fernando*
(1879).

55

Degas and the lure of the East

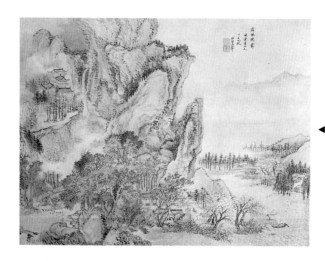

From the end of the 19th century, Chinese and Japanese prints were massively imported into Europe. The painters were very impressed by them, and Degas in particular studied their treatment of space.

How does Oriental perspective work? Very simply, in planes placed one after the other, because the Chinese and Japanese painted on rolls. These rolls were vertical, to be hung on walls, or horizontal, in which case they were looked at on a table. Because of this, there could not be a unified treatment of space the way there is in Western perspective. We find this superposition in Degas, though it is a little different: each plane corresponds to a moment in time, and is therefore incompatible with the next. But he borrowed more than that from the East. If we look at the double-bass, that neck that dominates the centre of the painting, does it not have the same function as the trees in the Chinese print?

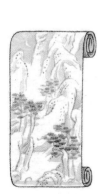

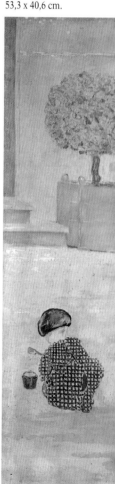

▲
Vertical rolls are hung on walls.
Horizontal ones are looked at on a table: one unrolls one side while rolling up the other. ▶

Pierre Bonnard ▶
(1867-1947).
Child making a sand-castle (c. 1894).
Size paint on canvas:
50 x 162 cm.

The door gives an indication of depth, the pinafore is very "flat."

56

In both cases, there is a vertical component that cuts through all the planes, linking them together. In *The Tub*, it is the table on the right that has this function.

a play on opposites

Degas studied Oriental prints and he also knew Renaissance painting, in which one sees the beginnings of perspective. Added to this, he practiced photography, which is based on the same optical construction as linear perspective, in that a single motionless eye unifies the subject. In this way Degas experimented with different ways of depicting space.

Almost all the artists of the late-19th century greatly admired Oriental prints, for they found in them an echo of their own interests: a new way of treating space, painting that took format into account, and colours that were applied in flat compartmentalized areas.

▲
Degas
Dancer,
Photograph.

Here Degas combined his two hobbies: ballet and photography.

Degas ▶
The Bass-player Gouffé
(c. 1870).
Preparatory drawing
for *The Orchestra of
the Paris Opera*:
11,9 x 18,4 cm.

The double-bass links the horizontal planes as the trees do in the print by Wang Houei.

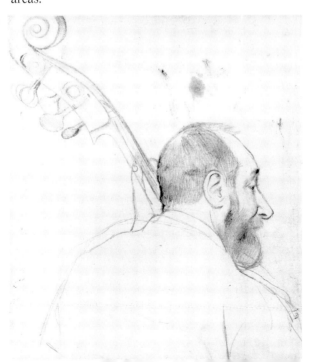

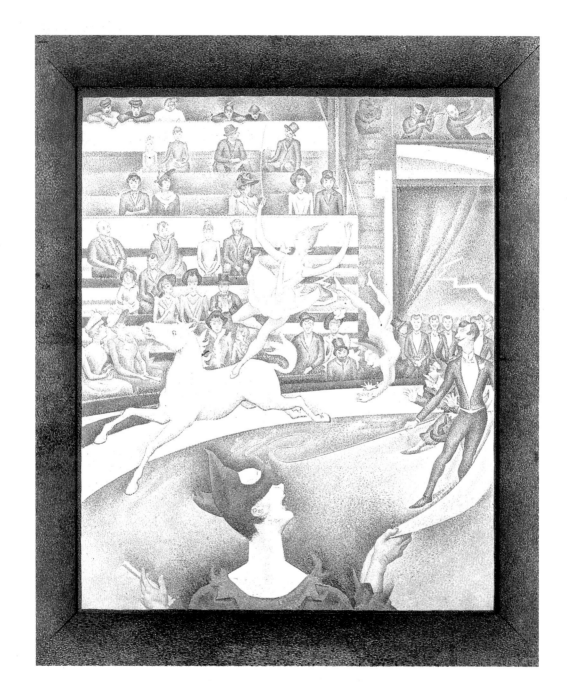

SEURAT

and the surface of the canvas

Seurat was born in 1859, and was therefore formed as a painter by the Impressionist movement. He was familiar with the concept that a painting transmitted a painter's instant impression, but what he wanted to do was to bring order into the brush-work and play of colours.

Seurat died of typhoïd fever at the age of thirty-two, leaving his last painting unfinished. Unfinished? How can we know that? Is it possible to imagine oneself completing those myriad dots? Seurat would have, for he was a perfectionist and an obsessive worker. Before his untimely death, he had painted over two hundred canvases, some of which are very large.

as if it were a show

Georges Seurat,
French painter
(1853-1891).
The Circus (1891).
Oils on canvas:
height: 1,85 metres,
width: 1,52 metres.

Despite being
unfinished, this
painting was shown at
the "Salon des Artistes
Indépendants" in
1891: Seurat was the
◄ leader of Pointillism.

This painting is of a circus scene with a clown in the foreground. By cutting him off at the shoulders, Seurat leads us to believe we could touch him. Yet we do not truly enter into the painting, because the dots are too visible, even from a distance. Besides, the frame is also painted, which is very unusual. It is treated with the same technique of small dots of colour. By painting the frame, Seurat was demonstrating that the painting, like the frame, is a tangible object and not just an illusion of something. This was the reason so many painters of the period chose this kind of subject. The spectator can no more enter a painting than he can get up onto the stage in a theatre.

**The Salon des
Artistes
Indépendants**
The Salon of
"independent artists"
was founded in 1884
by Seurat and his
group because they
were exasperated by
the official Salons.
This Salon, with no
selection committee
and no prizes, was a
great success with the
artists and the
informed public.

Seurat wanted to bring order to painting

Seurat greatly admired the Impressionists, but he was disturbed by the anarchy of all those "sensations" and "impressions." He wanted to get back to a powerful, unifying system, like that of conventional painting.

a theoretician of colour

A white horse, a trainer in a dark shiny costume, a clown completely dressed in red. This is what we would say if we were describing this painting. But we might also remark that the overall colour of each figure is arrived at by the juxtaposition of small dots of different colours that are neither "white", "black" nor "red." Where did Seurat get the idea for this technique? He found it in a book published in 1839, *On the Law of Simultaneous Contrast*, by a French chemist called Chevreul. He explained that the retina of the eye has three colour zones, and that the central optic nerve synthesizes the pure colours of the spectrum to produce every colour. Chevreul discovered that two pure colours placed next to each other produce a third in our eye. He called this "optical synthesis." To make the horse seem white and make it appear to stand out, Seurat used touches of white, yellow, blue and even red: and yet its colour looks natural! What Seurat wished for was that a painter should approach colour "scientifically." He wanted to avoid anything that was too emotional or too individual in an artist's activity. His dots, which are the smallest possible contact between the brush and the canvas, are much more "anonymous" than the Impressionists' touch.

shapes to be learned about

If we look at this painting carefully, we notice that the clown's hat and the pose of the circus rider have more or less the same "crow's foot" shape. Is there such a thing as a happy shape or a sad shape? Seurat believed there was. He worked out this theory with Charles

▲

The solar spectrum decomposed by the prism. It was the British physicist Newton who demonstrated in the 18th century that light was a mixture of colours that, when separated by the humidity of the atmosphere, produce the rainbow.

The Circus, detail of the upper part. ▶

The shoulders of some of the audience were also in the form of a crow's foot. The frame repeated certain colours from the painting, as in the shadows of the seating. In this way, Seurat put the painting and the frame on the same plane.

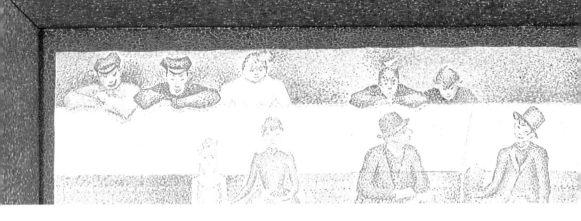

Henry, the author of the book *An Introduction to Scientific Aesthetics*. Both of them believed that shapes could be codified according to the effect they have on the spectator. This crow's foot was one of these codified shapes, and it was supposed to induce a sense of pleasure and fun. Did it really have this hoped-for effect? It is difficult to establish, but one thing is sure: the repetition of this shape unifies the composition of the painting, even if we do not notice it immediately.

dots on the frame too

Paintings have traditionally been enhanced by handsome gilt frames. Why did Seurat abandon this tradition and put *The Circus* in a frame that is reminiscent of a brilliant blue night? He was being faithful to his theories. Since the eye mixes colours, he feared that the colours of the painting would be altered by those of the wall on which it might be hung, of curtains, etc. To avoid this happening, Seurat painted the frame, selecting colours that would make the painting itself always appear the same, regardless of its surroundings.

Because the frame and the painting are treated with the same technique, there is a slight ambiguity about the painter's intention: was it that the surface of the painting is just as tangible as the frame? Or was it that the frame is as illusory as the circus scene?

In fact what it means is that the frame is not an accessory as had been believed up to then. Thanks to Seurat, it became as integral a part of a painting as the canvas and the paint.

The Circus, detail.

The clown's hat is a good example of one of those shapes that Seurat believed would have a positive effect on the viewer.
▼

The Circus, detail.

We find the crow's foot shape at several levels in the circus rider: her head and arms or her body and skirt.
▼

61

Seurat showed the parts of a painting

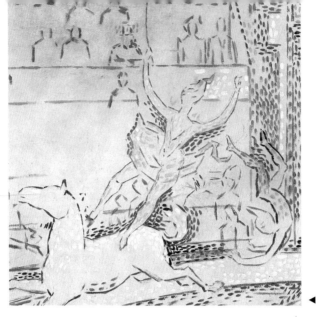

W hen Seurat exhibited his first Pointillist painting, *La Grande Jatte*, in 1886, he was immediately placed at the forefront of a movement that included Signac, Cross and Pissarro.
Why this success? Is there really a connection between art and science? In fact Seurat's theories led him to break up a painting and show all the parts of which it is formed: the touch, the colours, the frame, the canvas.

A long drawn-out job
It took Seurat two years to paint *La Grande Jatte*, his first Pointillist painting. It measures over two by three metres!

white as a colour

In the studies and preparatory drawings that he left, there are fewer, thicker brush-strokes, with the result that the colours are much more contrasted. Seurat also let the white of the canvas or paper show through. Naturally all the painters did this in their sketches, but did Seurat do it for the same reasons? No, because for him white was the synthesis of all the colours. If we compare the preliminary study with the finished painting, we realize that Seurat used the white ground as a colour in itself. The placing of the figures in the painting is the same, but the values of the colours in the sketch and the painting are different.

Henri-Edmond Cross ►
The Golden isles
(c. 1891/92)
Oils on canvas:
59 x 54 cm.

Cross purposely
made the horizon line
almost invisible. We
are disturbed by it,
and have the
impression of a wall
of painting that is
almost abstract.

"What the Impressionists did was to allow only pure colours onto their palettes," Seurat observed. "What they did not do that still needed to be done, was to respect the purity of these pure colours absolutely, and in all circumstances."

These pure colours are those that make up "white" light, the light of the sun. Seurat went back to the origins of colour, and this is why he used the white of his ground as if it were a colour. The sizes of the dots also play a part: a big dot in the sketch corresponds to a group of small ones in the final painting. Thus Seurat altered the colour of each dot in accordance with the final colour the spectator should see.

When we examine *The Circus*, we perceive the dots immediately, because Seurat adjusted their size in proportion to the size of the canvas. The bigger the canvas, the further away from it we tend to stand in order to see it as a whole. So that the Pointillism should remain visible, the painter had to bear this in mind. Seurat never allowed the spectator to "forget" the dots. In *The Circus*, we see the setting, the clown, the circus rider, etc., but the "nuts and bolts" of the painting are ever-present.

Henri Matisse
Luxe, Calme et Volupté (1905). Oils on canvas: 95,5 x 118 cm.

Matisse used a "reverse" Pointillism here. The brushstrokes are much too large and the colours are much too far away from each other for the eye to be able to mix them. It was an important choice, for 1905 was the year of the famous "Salon des Fauves", in which colour was used with complete freedom.
▼

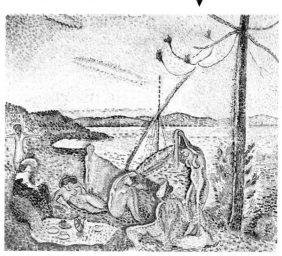

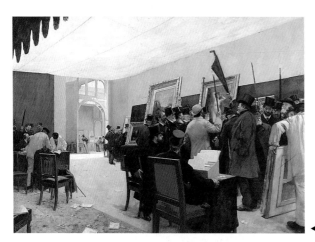

Henri Gervex
(1852-1929).
Le Jury de Peinture
(1885).
Oils on canvas:
299 x 420 cm.

It took several days
of walking past the
paintings propped
against the walls
for the selection
committee — *le jury* —
◀ to make its choice!

Henri Fantin-Latour ▶
(1836-1904).
*An atelier in
Batignolles* (1870).
Oils on canvas:
204 x 273 cm.

The painter is Manet.
Seated next to him is
the painter and writer
Astruc, and standing
from left to right are:
Schölderer, Renoir,
Zola, the collector
Edmond Maître and
Monet.

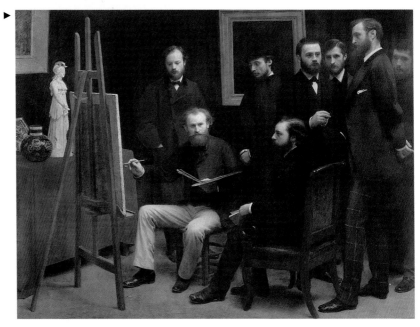

The artist
and his public

During the 19th century, the number of artists increased so rapidly and the Academy was so conservative, that the avant-garde was forced to find other ways of making itself known.

What had been the traditional career of a painter ever since the Academy was founded in the 17th century? He took an entrance exam to the École des Beaux-Arts which, if he was accepted, led step by step to the First Prize. Using the influence of his teachers, he was then allowed to exhibit at the annual Salon, where he won more prizes, found purchasers and received commissions from the State or private patrons. Lastly, he himself might even end up as a member of the Academy.

Young artists who had failed the entrance exam or were dissatisfied with the teaching of the established painters at the Beaux-Arts, chose other avenues. They studied the old masters in the Louvre, they practised life-drawing at one of the independent academies for a modest sum, or they worked out of doors, from life. Naturally, they frequented each other: they were to be seen in the cafés discussing their work or new ideas. With them were young writers who would become critics, and rich young people who would become collectors.

What could an artist do after he had been rejected by the selection committee of the Salon, when the Salon was the only place in which a painter could exhibit his work and reach the public?

The solution was the press. The Salon was a major social event, and every newspaper had its own "art specialist." These journalists, the "critics", kept up with the developments in art throughout the year, and their readers expected them to share their experience, and to be their "professors of good taste", as it were.

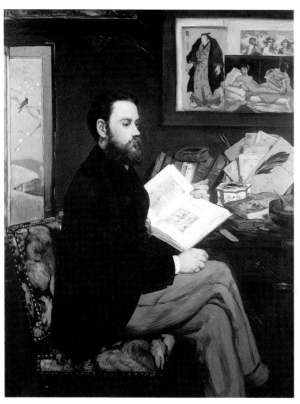

◀ **Édouard Manet
(1832-1883).**
Émile Zola (1868).
Oils on canvas:
146 x 114 cm.

One can see some
Japanese prints and a
reproduction of
Manet's *Olympia* on
the wall behind Zola.

▲

**Jean Benjamin-
Constant**
(1845-1902).
Alfred Chauchard
(1896).
Oils on canvas:
130 x 97 cm.

A great mid-19th
century collector,
Chauchard made a
major donation to the
Louvre.

Édouard Manet ▶
(1832-1883).
A café (1869).
Pencil and ink
on paper:
29,5 x 39,5 cm.

Artists, critics and
collectors met in the
cafés where they spent
long hours in
discussion.

Some critics of the time, such as the poet Baudelaire or the novelist Émile Zola, have remained famous to this day because they were also well-known authors. Because they were famous, they were able to take non-conformist stands in the press. Encouraged by their support, artists tried less and less to be accepted by the Salon, and began to show their work elsewhere instead.

These new places to exhibit their art were haphazard at first, like the photographer Nadar's establishment, where the first Impressionist exhibition was held. Before long they began to specialize and turned into art galleries. Some have remained famous because they were run by people with remarkable flair, both in the artistic field and in the field of business — for one had to be careful! These "private" but commercial exhibitions were copiously written up in the press; as a result, the public flocked to them.

Thus the avant-garde abandoned the Academic system that had reigned over the previous two centuries in favour of the "press-gallery" tandem, and entered a new system that still holds sway today: that of the "dealer-and-critic."

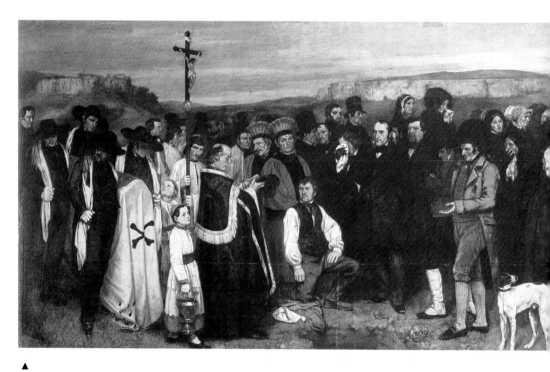

▲

Gustave Courbet,
French painter
(1819-1877).
Funeral at Ornans
(1849/50).
Oils on canvas:
height: 3,15 metres,
width: 6,68 metres.

*Gustave continues to
be on everyone's lips in
artistic circles. . . .
There are drawing-
rooms in which it is
said that Courbet was
a journeyman-
carpenter or bricklayer
who, one fine day, fired
by his genius, began to
paint and produced
masterpieces from the
word go. In others,
it is held that he is a
dreadful Socialist and
that he is the leader of
a gang of conspirators.
This can be clearly
understood from his
paintings, they add.
That man is a savage...*

Letter to the artist's
sister

COURBET
and personal publicity

▲

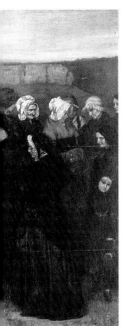

Courbet is one of the most colourful figures of the 19th-century artistic world. A genius according to some, perverse and repugnant according to others, he unleashed violent passions amongst critics and caricaturists!

Funeral at Ornans was the first of Courbet's paintings to provoke a scandal and thus draw attention to its author. Courbet was thirty-one.

What was it about the painting that caused such a wave of indignation? A funeral in a little village in Eastern France, Ornans, the village where Courbet was born. A large, horizontal format with a procession of people. The subject seems very ordinary, and yet the manner in which it was treated made it unacceptable. The painting lacked visible emotion, it lacked grandeur, and it was not solemn or sentimental enough. In short, it was considered vulgar and, to add insult to injury, the priest was as ugly as the rest of them.

a scandalous realism

Courbet, however, was merely painting an ordinary funeral, that of a provincial bourgeois, accompanied to the grave-side by other provincial bourgeois, by some labourers in their Sunday best, by a few village notables and a country priest. Therein lay what would be called Realism, and therein lay the scandal! If the painting had such a devastating effect, it was also because Courbet had not had a conventional career. He never attended the Beaux-Arts, he never had a reputable teacher. He was thus almost self-taught, and was not in the least embarrassed about it.

**The contradictions
of the Academy**
Funeral at Ornans had been selected for the 1850/51 Salon by a committee that included Academy members. So it could not have seemed so very bad to some!

Courbet and Realism

Funeral at Ornans, detail.
The priest and the beadles.

It was the faces of these villagers that shocked people the ◀ most.

Jean-François Millet
The Spinner, Auvergnat goat-girl (1868/69).
Oils on canvas:
92,5 x 73,5 cm.

No prettying-up for this hard-working country girl.
▼

Isidore Pils
Death of a Sister of Charity (1850).
Oils on canvas:
241 x 305 cm.

Dramatic lighting, graceful, moving poses, obvious piety and sentimentality: this was tasteful mourning!
▼

Every inhabitant of Ornans in 1849 had wanted to pose for Courbet's painting: the priest Bonnet, the cross-bearer Colard, the sacristan Cauchi and the beadles in red — the vine-worker Muselier and the shoemaker Clément. They were all very proud to be included!
But it was precisely these people, all members of the church, that struck Parisian critics most strongly. They found them ridiculous and verging on caricature. Some read an anti-clerical message into the painting, which was a highly sensitive subject. It was because of this

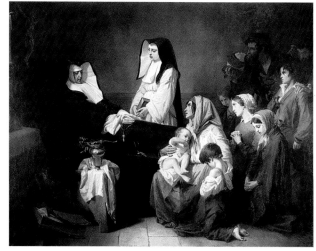

The composition
The way Courbet placed all the figures on the same plane was considered to be a sign of his lack of imagination by the majority of the critics, whereas the accent is on the directions in which they are looking. ▶

last fact that some hated the painting and others loved it. This is how the Realist movement began: with a misunderstanding. Is it conceivable that Courbet would have asked his friends to pose for him in order to make them look ridiculous? Of course not. It is true that he was something of a Republican, like most of the avant-garde artists, but this was certainly not his main concern when painting. He had written to a friend about his desire to paint a large historical work — the noblest of the genres. It goes without saying that he wanted to do it in his own way.

monumental but sober

When we look at the dimensions of the painting, we realize that the figures are almost life-size, which makes them arresting. They are not placed artificially, they are simply standing in a line, as they would be if they were in a funeral cortege. There are no exaggerated gestures or dramatic poses and their expressions are restrained because it does not do to display grief. What the Realists were reproached for, therefore, was for painting "rugged" scenes, making no attempt to render them more attractive. Did Courbet like to shock people? Not at first, but once he realized just how hypocritical people could be…he probably grew to enjoy provoking them, by showing prostitutes on the banks of the Seine, for instance, or worse!

▲
Courbet
Portrait of Champfleury (1854).
Oils on canvas:
46 x 38 cm.

Champfleury was a friend of Courbet. He was considered to be the theoretician of Realism.

71

Courbet and the uses of scandal

Gill
Caricature in *Le Salon pour Rire* (1868).

A fattened-up and self-satisfied Courbet is shown leaning on the two paintings he presented that year: *The Hunted roe-buck* and *The Alms of a beggar in Ornans.*

The critic Gustave Planche wrote in 1857: "At first I thought that he chose scandal as a route to fame. I have now changed my mind, for his name is well-known and yet he perseveres."

The scandal that broke out over *Funeral at Ornans* was to be repeated throughout his life, but Courbet learned to use scandal to his advantage.

The critic Clément de Ris commented: "His talent is unequal, bizarre, not very pleasant, undeniable and curious to see." Another critic, Delécluze, writing about a figure in *The Bathers* of 1853, said: "Courbet seems to suffer from some disorder of the organ of sight. . . . His *Bather* is so monstrously ugly that she would make a crocodile lose its appetite." But as soon as Courbet painted something other than people, everyone was unanimous in their praise for his genius. Every landscape he produced, every hunting scene that he presented at the Salon, was admired and purchased.

Yet his technique never changed: his touch was thick and flat, for Courbet was the first painter to use his palette-knife to apply paint. It must therefore have

Bertall
Caricature of *The Peasants of Flagey returning from the fair* by Courbet, in *Le Journal pour Rire* (1850).

been some of the critics who suffered from a disorder of the organ of sight....

Courbet did not attend the Beaux-Arts. He studied life-drawing at the *Académie Suisse*, an independent studio, and he copied the works of the Dutch masters in the Louvre. Self-teaching was unusual in mid-19th century, and was disapproved of: it was seen as a slight on the Beaux-Arts and its powerful professors.

a "wild-cat" exhibition

There was worse to come. In 1855 the huge Universal Exposition rejected some of his favourite paintings. So Courbet built a temporary structure on the Avenue Montaigne, facing the official gallery, and held his own exhibition! The entrance fee was 1 franc, and one could purchase a catalogue written by Champfleury, and photographs of Courbet's paintings.

This was a historic occasion: it was the first time that an artist relied solely on his reputation and on the press to combat the inadequacy of public institutions.

▲
Courbet
Portrait of Bruyas
(1853).
Oils on canvas:
91 x 72 cm.

Alfred Bruyas lived in Montpellier. He was a great collector of contemporary art.

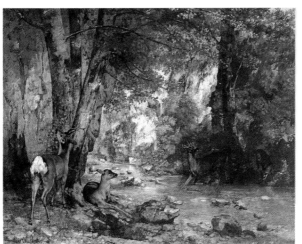

◀ **Courbet**
Covert of roe-bucks at the stream of Plaisir-Fontaine (1866).
Oils on canvas:
174 x 209 cm.

This style of painting was universally admired and assured Courbet's income.

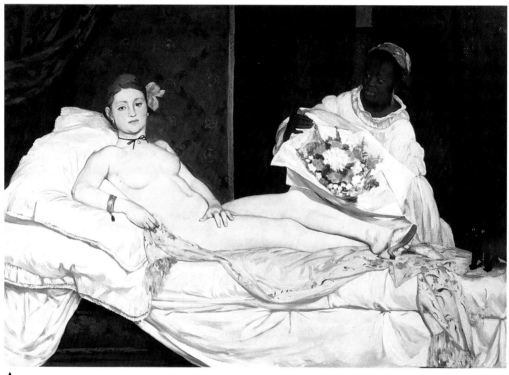

▲
Édouard Manet,
French painter
(1832-1883).
Olympia
(1863, 1865 Salon).
Oils on canvas:
height: 1,30 metres,
width: 1,90 metres.

The writer Théophile Gautier saw *Olympia* as "a sickly model lying on a sheet. The skin tones are dirty, the modelling non-existent. There is nothing more to this painting than a desire to attract attention at any price." A critic called Ernest Cheneau spoke of an "almost infantile ignorance of the first notions of drawing" and of a "set purpose of being unbelievably vulgar. Manet", he continued, "manages to provoke almost indecent laughter with this comical creature he calls *Olympia*."

MANET

and the dealer-critic tandem

<u>Manet dreamed of an uneventful career, but his paintings provoked an outcry from the very beginning, culminating in the scandal over *Olympia* in 1865, and so he was forced to make the best of it!</u>

One of the more reactionary critics of the time, Paul de Saint-Victor, wrote: "The crowds press to see Manet's decadent *Olympia* as if they were visiting the morgue." How could he compare *Olympia* to a corpse? Mainly because her very white skin went against the variety of pink tones in which flesh was habitually treated. The defenders of tradition decided that *Olympia* was both "badly painted" and "too realistic."

an embarrassing presence

She was thought to be "badly painted" because there were not enough of the pretty tints people were used to, and because the scene was "blocked off" by the drapes in the background and was lacking in the picturesque. Everyone unanimously dubbed it "too realistic" because they all agreed the lady was indecorous. Her cold stare, her black cat, the Black woman bringing her the flowers: *Olympia* reminded everyone a little too forcefully of that bane of society — prostitution.

Manet was the first to be taken aback by these criticisms. He had not intended to shock the general public, and he was hurt by this fresh scandal. Zola was among his few champions: "I know for certain that you have succeeded admirably in producing the work of a painter — a great painter — and that you have energetically translated the realities of light and shade, the realities of objects and living creatures, into a personal language."

Was Manet an Impressionist?
It is often held that he was, probably because the Impressionists claimed to have been influenced by him. In the 1860s, Manet was considered a Realist.

▲
Manet
The Cats (1868),
detail.
Etching.

75

Manet and raw painting

Olympia, detail.

Described by Zola as "yellow patches, blue patches, green patches"...

Who is *Olympia*? Is she a "nude" in the sense the word is given in art history, or is she simply a naked woman? It so happens that Manet was painting variations of classical works. In 1863, his "model" for *Luncheon on the Grass* was *Concert Champêtre* by Titian, one of the greatest painters of the Italian Renaissance. For *Olympia*, he turned to *Venus of Urbino* by the same painter. In both cases, the placement of the figures was so instantly recognizable that it could not escape the cultivated public of the period. Manet teased a public that was in the habit of judging everything by the past. He seemed to be saying: you see? I have composed my painting like Titian, whose talent is undeniable — what more do you want?

Cham
Caricature of *Olympia* in *Le Charivari* (1865).

Alexandre Cabanel ▶
Birth of Venus (1863).
Oils on canvas:
300 x 218 cm.

A languorous Venus with half-closed eyes, but surrounded by *putti* painted in a very conventional manner. The very conservative Napoleon III immediately bought this painting!

Added to a touch that the critics qualified as "flat", his paintings were shocking because he gave his subjects no "alibis" in a century that was extremely prudish.

an over-audacious nude

Titian's paintings
Manet had been able to study these closely in the Louvre, which had already acquired them, and where Manet frequently worked.

People enjoyed paintings of lightly-dressed, pretty women, but out of respect for public morals, these had to be given a cultural pretext. Painting has always abounded in gods and goddesses, frequently nude, but this was what was called "classical nudity", and was therefore permissible. Manet, on the other hand, mixed classic compositions with contemporary "insignia." *Olympia* is not a nude goddess, she is wearing slippers, a necklace and a bracelet, which make her into a naked woman. This is also true of *Luncheon on the Grass*, in which the woman's nudity is all the more shocking because she is sitting next to two fashionably dressed gentlemen.

The similarity of the compositions and the subjects to Titian's paintings underline the differences in their concept and treatment. What strikes the viewer most is their reality as opposed to illusion. They are absolutely "raw" paintings.

Alibis
"The public will accept monsters with goats' hoofs abducting fat women with no clothes on, but it does not want to see the suspenders worn by Courbet's *Young Women on the Banks of the Seine*. It adores the Madonna with her baby Jesus, but is not interested in seeing a country-woman feeding her child."

Thoré-Burger

◀ **Manet**
Luncheon on the Grass (1863).
Oils on canvas:
208 x 264 cm.

This painting was rejected by the Salon.

Manet fought the good fight

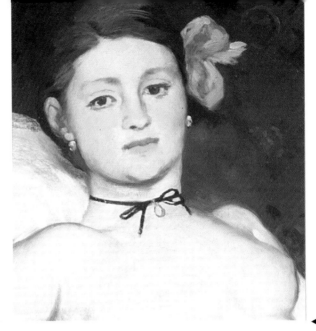

Olympia, detail.

Look at the young woman's face: her lips are two fine pink lines, her eyes are reduced to a few black strokes.

◀ Émile Zola

Nadar
Zola.

Photograph inscribed: "Truth is on the march, and nothing can stop it."
▼

Faced with the scandal over his *Olympia*, Manet wrote plaintively to Baudelaire, who was in Brussels: "I truly wish you were here, my dear Baudelaire, for there is clearly someone who has got it all wrong."

In his reply to this letter, the poet gently teased the painter for his precocious ambition. And yet Manet was asking an interesting question: who is right? What was the position of an artist in the face of an ill-informed public and blinkered institutions? Manet provided the answer in 1867, when he staged a "wild-cat" exhibition, as Courbet had done in 1855 and as the Impressionists would do at Nadar's establishment in 1874.

"images d'Épinal"

Manet was some ten years older than the "real" Impressionists, he had never been a landscape artist as they had in the beginning, and he did not paint like them. Zola attempted to define his "special realism": "People joke that Édouard Manet's paintings remind them of prints from Épinal, and there is a lot of truth in this joking which is in fact praise. In both instances, the techniques are the same in that the colours are applied in flat areas, but where the printers in Épinal use pure

The general public
Zola noted that the general public believed in the existence of "absolute beauty": "Circumstances have decreed that the standard of beauty is Greek art, in whose name the art of every other epoch and country is strangled — especially modern art!"

colours, without giving a thought to their values, Édouard Manet multiplies their tones and places them in the correct relationship to each other. It would be much more interesting to compare his simplified canvases with Japanese prints which resemble them in their strange elegance and magnificently spare forms." Manet approved of the Impressionists, though he never showed his work at their exhibitions. Nevertheless, he was a pillar of strength at their gatherings, and so, in the eyes of the public, he had all the trappings of a "gang-leader!"

Manet the menace

His place in the history of contemporary art is assured. The day someone writes about the developments or deviations of French painting in the 19th century, they will be able to by-pass Cabanel, but they will have to take Manet into account.

The art-critic
Castagnary, 1892

And what a gang they were! The Impressionists were accused of being dangerous Anarchists, of leading France to her doom and her youth into debauchery. To put it more accurately, it was with their arrival on the scene that the academic system and the retrograde Salon began to fall apart. From then on, artists would rely on a powerful combination: the dealer, who exhibited and sold a painter's work, and the critic, who roused opinion with his articles, announced exhibitions, explained the artist's work and intentions, and last but not least, whet the appetites of art-collectors.

▲
Gustave Caillebotte
(1848-1894).
Self-portrait.
Oils on canvas.
Private collection.

The State refused
the better part of his
extensive collection
of paintings.

Pension Gloanec
Photograph.

In Pont-Aven in
Brittany, the artists,
among them Sérusier
and Gauguin, met in
a café as they did in
Paris. ▶

▲
Vincent Van Gogh
(1853-1890).
Père Tanguy (*c.* 1887).
Oils on canvas:
92 x 73 cm.

Père Tanguy was
an artists' materials
retailer who often
exchanged his wares
for paintings, which
helped the poorer
artists. He claimed
to re-sell these works,
but he was a bit of a
secret collector!

Painting comes first

By the end of the 19th century, the avant-garde artists no longer strived to be accepted by an academic system that demanded a blind submission to the rules of the past from its adherents. They met in the cafés, and some of the critics recommended them to patrons and galleries. The avant-garde rode alone, and one had to enjoy taking risks to keep up with them.

The risk was not a financial one, for the artists sold their works very cheaply. It was more of an intellectual risk, since this kind of painting was seen as the product of deranged and degenerate minds. It was generally accepted at the time that the object of a painting was the reproduction of things with photographic realism. Where was the need for that, since photography itself was available?

Besides, why reproduce what we already know? Like the scientists and philosophers of the time, artists had to discover new ways of describing the world around them. From one point of view, of course, artists had always been inventors. What had changed by the end of the 19th century, was that painters believed that the sources of their inventiveness should only lie in art itself. They abandoned God and the State, which had been almost obligatory points of reference in the past, and made the component parts of a painting come into play: colour and its ranges, the painter's touch, the support and its limits.

Before the 19th century, Royalty and cultivated ministers had traditionally supported contemporary art, added to which, art was reserved for the aristocracy. During the 19th century however, democracy made culture

Henri Rousseau, ▶
called **Douanier Rousseau**
(1844-1910).
The Snake Charmer
(1907).
Oils on canvas:
169 x 189 cm.

A one-time customs
officer — *douanier* —
and self-taught, Henri
Rousseau is one of the
unclassifiable artists
of the late 19th
century.

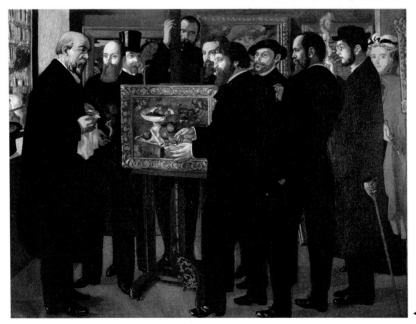

Maurice Denis
(1870-1943).
Homage to Cézanne
(1900).
Oils on canvas:
180 x 240 cm.

In the art dealer
Vollard's
establishment, from
left to right: Odilon
Redon, Vuillard,
the critic Mellerio,
Vollard, Maurice
Denis, Sérusier
◀ and other artists.

available to an ever-increasing number of people. Paradoxically, by the end of the century, it was also to bring about a separation between avant-garde art and the general public.

Why this divorce? Because the institutions dedicated to the support of art had been totally out-distanced. What were the reasons? Well, many of the major artists had learned to paint through unorthodox methods, spending little or no time at the Beaux-Arts, whose teaching had become out-dated. This was the case for artists such as Gauguin and Douanier Rousseau, for instance.

Another even more glaring example is the affair of the Caillebotte bequest in 1894. Caillebotte was a painter, but also a major collector of the works of his friends the Impressionists. On his death, he generously bequeathed his collection to the Nation — which turned it down! As incredible as this may seem, the Board of the Musées de France — which governed all of the French museums — supported by the Academy, felt that it would be demeaning to show Impressionist works, and thereby rejected the bulk of the bequest!

In those days, children were not taught art history at school, which meant that the general public was left to its own devices in that field. It was forced to rely on the critics to develop its tastes and only conquered the heights of "art" after a bitter struggle — that was the price of freedom...

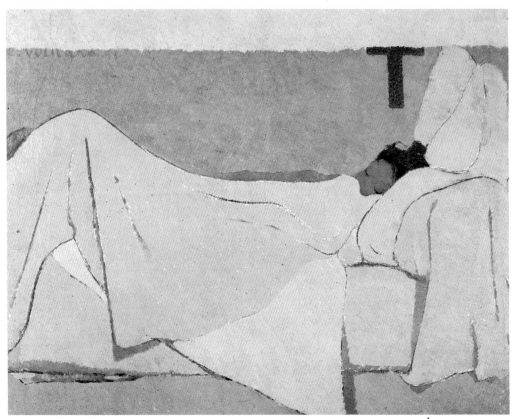

It is obvious how much this painting owes to Japanese prints and to Gauguin: flat surfaces painted with a discreet touch, an almost total absence of shadow, a flattened perspective achieved by superposition, a minimum of essential lines.

▲
Édouard Vuillard, French painter (1868-1940). *In Bed* (1891). Oils on canvas: height: 74 cm, width: 92 cm.

VUILLARD

and spreads of colour

In Bed: at first glance this is an intimate scene painted in the discreet colours one might expect. In fact, Vuillard unveiled some painters' secrets in this canvas, such as the importance of the colours and the support.

The colour range
In art, this musical term describes the more or less extensive number of colours used by a painter.

Afew beige tones, some of them with touches of yellow, a more sustained brown for the sleeper's face and the partially visible cross, a few shaded lines. Was it a fear of using bright colours that led Vuillard to paint such a monochrome painting? On the contrary! This narrow range, this economy of colour, go to prove that he had absolute control over its power.

the colours do everything

The painting is composed in such a way that anything that might have constituted a vanishing line, like the ends of the bed, is not shown. Did he use a directed light to make the volumes stand out? No, there are some almost imperceptible shadows thrown by the sheets, and that is all. Vuillard succeeded in giving the impression of volume and space without using any of the traditional means, by simply keeping to this narrow range of colours. Vuillard was a great admirer of Gauguin, incidentally, and belonged to the Nabis, a group which had formed round a painting by Paul Sérusier, _The Talisman_, painted under Gauguin's supervision.
In 1892, a year after he painted _In Bed_, Vuillard began to discard the true colours of objects in favour of a play on the clashes of strong colours, straight from the tube. He was to be among those Fauves who caused such a violent outcry at the 1905 Salon.

A long career
From 1899, Vuillard was handled by the gallery belonging to the Bernheim brothers. He was to remain with them until 1914. In 1937, he entered the Academy.

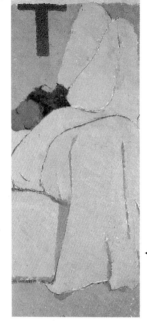

◀ *In Bed*, details.

These vertical "slices" of the painting clearly show the superposition of the areas of colour. They would be incomprehensible were they not placed in a composition that encloses them and gives them meaning.

Vuillard unveiled painting

The signature
The signature in this painting adds another level of ambiguity to it: one could think that the strip along the top is the bare canvas.

We often use the word "canvas" when speaking of a painting, and canvases are often made of woven linen. As it happens, this particular canvas contains a lot of linen! Sheets, coverlets, pillow-cases and a bolster, a curious strip across the top that is probably a tester, since it masks the top of the cross hanging on the right-hand side of the wall behind it. In French, the same word, "toile", is used for canvas and linen, which results in a play on words in this painting — a canvas full of "canvas", as it were — which it is hard to believe the painter did not intend.

a bed full of illusions

In Bed is composed of a series of planes: the wall, the cross, the tester, the top sheet draped over the sleeper's bent knees, the mattress covered with the undersheet, and the bedstead. There is a relationship therefore between the subject and the artist's main concern, the planes. What really interested Vuillard was the organization of these various planes on the plane of the canvas, that piece of linen attached to its wood stretcher and hung vertically on a wall which the viewer tends to forget.

86

The green signature placed at the junction of two of those planes is very striking. By placing his signature in such an unusual spot and making it so obvious, Vuillard was reminding us that we should not be taken in by the "illusion" of what we are seeing, that we should be aware of the painting itself — the canvas — above all.

We understand, therefore, why the painter chose such a narrow range of colours. Nothing distracts our attention, we can see that this assembly of planes — both vertical and horizontal in reality — is composed of very little: an arrangement of surfaces on a support, a few lines, a few shades of colour.

Félix Vallotton ▶
The Ball (1897).
Cardboard:
46 x 61 cm.

The disposition of the planes in this painting is disorienting. We realize nevertheless that we are supposed to be seeing the child from an upstairs' window.

Henri Matisse
The Dance (1932).
Oils on 3 canvas panels:
340 x 387 cm,
355 x 498 cm,
3,33 x 391 cm.

Treated in flat areas of colour, the figures spill out of their support, giving the impression of movement.
▼

Vuillard and the minor arts

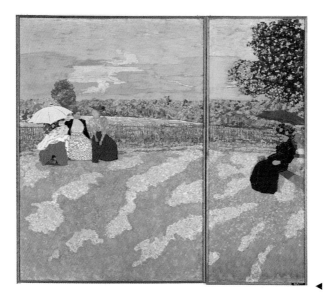

V uillard produced more than just paintings. Like
many of his contemporaries, he was interested in what
are called the "minor arts", such as interior decoration
and illustration.
The Conversation and *The Red Sunshade* are two of
nine panels by Vuillard that decorated Alexandre
Natanson's dining-room. Natanson was an art collector
and, with his two brothers, he published an important
avant-garde review: *La Revue Blanche*. All the major
writers and artists collaborated on it, including Vuillard.

walls to decorate

La Revue Blanche
Founded in Brussels
in 1889, *La Revue
Blanche* was published
in Paris from 1891 to
1903. It was one of the
most important
reviews of the period.

In the past, the State regularly commissioned artists to
decorate interiors, but from the mid-19th century,
these commissions only went to the more conservative
painters. The general public was nervous of the avant-
garde artists, for there was a yawning gulf between
them. Yet it was at this precise moment that artists
began to militate in favour of art becoming a part of
daily life. It was their way of claiming a role in society.
Vuillard worked for *La Revue Blanche*; he also produced
backdrops and programmes for the Théâtre de l'Œuvre,

an avant-garde theatre started by his friend Lugné-Poe, as well as creating large wall paintings for his favourite patrons.

None of those who, like Vuillard, demanded "walls, walls to decorate", considered this to be a minor art. They believed that an artist had a place in society, and that he could influence it with quality works, even when that society either ignored him or laughed at him.

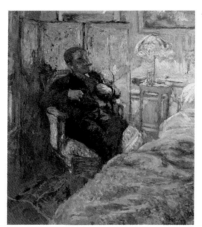

◄ **Vuillard**
Romain Coolus (1906).
Cardboard:
74 x 68 cm.

Coolus wrote for *La Revue Blanche*. Vuillard specialized in this kind of intimate portrait.

Henri de Toulouse-Lautrec
La Chaîne Simpson.
Advertisement (1896).
88 x 124 cm.

Toulouse-Lautrec was not too proud to draw objects that were not cultural!
▼

Henri de Toulouse-Lautrec
Advertisement for *La Revue Blanche* (1895).
1,30 x 0,95 cm.
▼

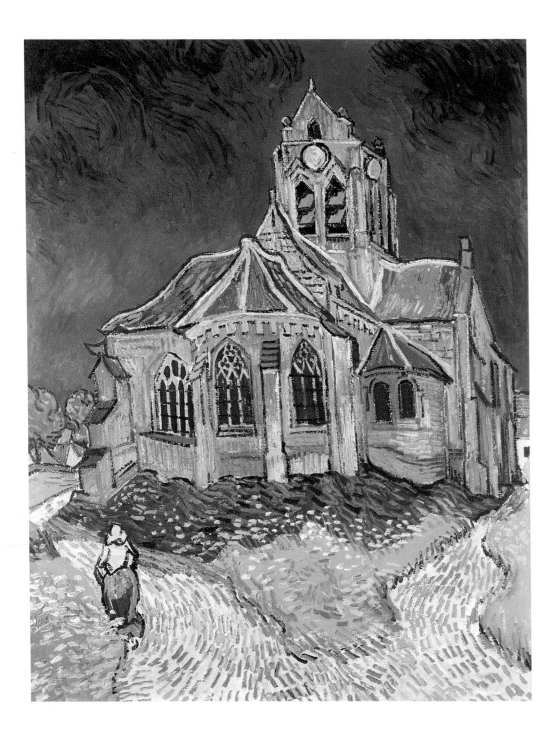

VAN GOGH

and the touch as a language

Vincent Van Gogh committed suicide in 1890, not far from the church in this painting, putting an end to a tragic life that had become the subject of common gossip. His art remains, and it is not the work of a madman.

Vincent Van Gogh
in a self portrait
aged 35.
Oils on canvas:
49,9 x 60,5 cm.

What is the most striking feature of this painting? The colour, or the touch? The almost blinding green of the grasses in the foreground, the blue sky turning to black? Or else the traces of his gestures while painting: short, spaced touches, sheaves of long strokes? In fact both these characteristics are equally striking, so it is up to the individual to choose which he prefers. Colour is as important as touch for understanding Van Gogh's paintings and the effect he had on early 20th-century painters.

accelerated painting

The fact that colour and touch are so closely linked is due to the speed at which Van Gogh worked: "I place irregular strokes on the canvas and leave them as they happen. Patches of colour applied in thick layers, bits of canvas left bare here and there, with whole sections left unfinished, repetitions, barbarisms... By always working on the spot first, I try to capture the essentials in the drawing — I fill it in later . . . also with simplified tones." Are his colours absurd? Is the church unrecognizable? And what about the woman on the path? No, they are simply slightly deformed and exaggerated. Van Gogh treated everything as expressively as possible, because he was attempting to communicate something — not what he saw, but how he felt when he saw it.

◀ **Vincent Van Gogh**, Dutch painter who lived and worked in France (1853-1890). *The Church of Auvers-sur-Oise* (1890). Oils on canvas: height: 94 cm, width: 74 cm.

Vincent

91

Van Gogh, the touch and the surface

For Van Gogh paint was a thick, coloured material to be spread over a canvas with relish.

Here is how he painted trees: in 1880, he wrote to his brother Theo: "I started them with my brush, but because the ground was already sticky, my brush-strokes just melted away. It was then that, squeezing the tube, I laid on the roots and trunks, modelling them a little with my brush. Yes — here they are — they spring up, they are firmly rooted. In some ways, I am glad I never learned to paint, for perhaps I might have let effects like these pass unnoticed."

It must be said that Van Gogh failed to hold out for longer than three weeks in the atmosphere of a studio. This was why he taught himself when he decided to become a painter at the age of 27. He copied engravings sent to him by Theo and sketched out of doors. He treated his drawings with the same touch as his paintings.

Mad about brushes
A walking companion said of Van Gogh that "he became abnormal as soon as he touched a brush: he replaced drawing with colour."

a raised surface

Van Gogh worked very fast. The first few brush-strokes delineated the scene: a fork in a path, a church. The strokes that he used afterwards to "fill-in", as he put it, blended the initial strokes into the overall surface. In *The Church of Auvers*, the brush-strokes follow the direction of each path like footsteps, build the church

as if with bricks and whirl turbulently across the sky. This was how he provided volume and space. The pencil-strokes in *Père Éloi's farm* depict the furrows, the grass and the smoke in the same way.

Although the brush-work constructs the painted object, the touch is so thick and dominant that it constantly reaffirms that the painting in itself is more important than the subject. The light plays on the raised surface of the paint and what we notice first, before a picture of a landscape, is the paint in which the painter has left his imprint.

Van Gogh said that he followed no established method in his work, but the absolute mastery of his touch and the liberties he took with colour are apparent in all his works. His "spontaneity" was perfectly thought out, and had been trained over long years of solitary apprenticeship.

A prolific painter
When he lived in Auvers, Van Gogh produced about two paintings a day.

The Church of Auvers, detail.

The direction of the brush-strokes depends upon the object that is painted.
▼

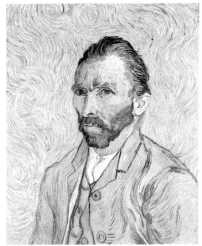

▲
Van Gogh
Self-portrait (1889).
Oils on canvas:
65 x 54,5 cm.

The texture of the background is as important as the portrait itself.

93

Van Gogh and the power of art

▲

Theo Van Gogh supported his brother throughout his life. He did not survive him long: he went mad and died a year after Vincent's suicide.

When we look at *The Church of Auvers*, we sense that Van Gogh was trying to tell us something. Is this because of the forked path or the darkness of the hopeless sky?

There is no need for a specific reason, for it is known that Van Gogh was convinced that art has the power to change the world and to throw light on its beauties and imperfections.

In Paris, he had wanted to set-up an artists' co-operative that would produce lithographs of old masters for the poor. He wrote also: "I do all I can to make my paintings look their best in a kitchen, and maybe one day I shall discover that they look just as good in a living-room."

Van Gogh sometimes described his intentions in a painting in his letters to Theo. For example, writing about *A café at night* in 1888, he said: "I have tried to express our terrible human passions with the red and the green. The room is blood-red and muted yellow, with a green billiard table in the middle and four lemon-yellow lamps giving off orange and green rays.

◄ His letters to Theo enable us to follow Vincent's development: illustrated here is a drawing of the composition of his palette.

Van Gogh
The Italian woman (1887).
Oils on canvas:
81 x 60 cm.

The face and hands are treated in the same way as the rest, using the same colours. ►

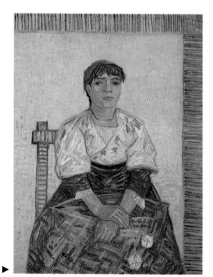

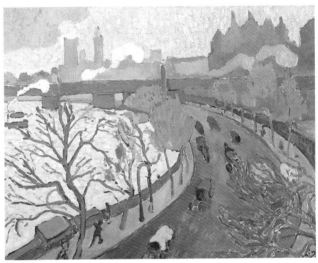

▲
Edvard Munch
The Scream (1893).
Oils on canvas:
91 x 73 cm.

This Norwegian
painter was also
claimed as an
"ancestor" by
the Fauves.

Everywhere a combat and an opposition of the most dissimilar reds and greens, in the little figures of the sleeping delinquents, in the sad empty room... I have tried to show that a café is a place in which one can be ruined, go mad, commit a crime."

the clash of colours

It is not so much each colour — which are not real in any case — that is important, it is this "combat", this "opposition", or else an agreement. It was through them that Van Gogh hoped to reach the viewer, and it is this that explains some of his deformations. He described this using the portrait of a friend as an example. He had begun by painting it "faithfully" and then, saying "I shall now become an arbitrary colourist," he increased the yellow of the sitter's blond hair, and, as a background, "infinity . . . in the richest, most intense blue I can achieve," resulting in "a mysterious effect like a star in the blue depths of the sky." It is the way he manipulated colour according to emotion that the Fauves would lay claim to in 1905. They felt an artistic kinship with Van Gogh because he carried colour to extremes in his paintings.

▲
André Derain
Charing-Cross Bridge
(1906).
Oils on canvas:
81 x 100 cm.

A typically Fauvist painting, in that it totally abandons the real colour of objects.

The more ugly, old, degenerate and ill I become, the more I want to take revenge by producing brilliant, harmonious, resplendent colours.

Van Gogh

95

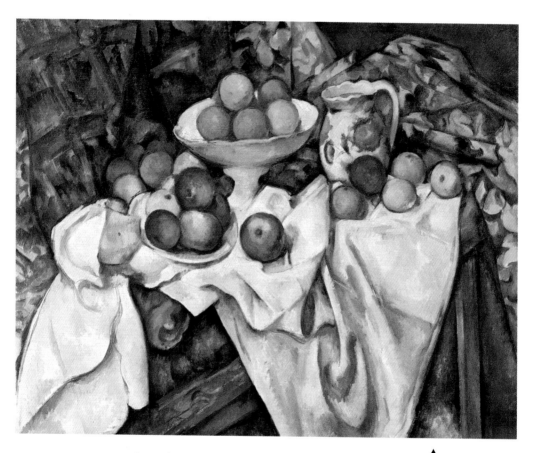

When Cézanne exhibited his work with the Impressionists in 1874 and 1877, the critic Georges Rivière wrote: "The artist who is attacked the most, who has been the most badly treated by the press and the public over the last fifteen years, is Mr. Cézanne. There is not an insulting epithet that has not been attached to his name, and his works have raised laughter that can still be heard today." Cézanne was only accepted by the Salon once, in 1882.

▲
Paul Cézanne, French painter (1839-1906). *Still life: Apples and Oranges* (*circa* 1895-1900). Oils on canvas: height: 74 cm, width: 93 cm.

CÉZANNE

and the new century

<u>Cézanne was the eldest of the avant-garde artists of the
turn of the century, and yet it was he who opened the
doors to the 20th century.</u>

The plate is seen almost completely from above and
tilts to the right; the fruit dish is also seen from above,
but it tilts to the left and its stem is seen from the front.
We can see that there is a table, but it is at a peculiar
angle, added to which, the white tablecloth does not
change direction as it falls over its edge. What is the
exact position of that sort of carpet at the back? All this
instability reminds us of the Impressionists' mobile
eye, does it not? Except that everything in this painting
is much more striking and radical.

misunderstood by all

Cézanne said: "I shall
astonish Paris with an
apple." The painting
"revolves" around
apples and oranges.
Since they are round
fruits, we can never
know from which
angle we are seeing
them.

Cézanne had an ambition: "To make something as solid
and lasting as art in museums out of Impressionism."
He knew the Impressionists' work well, having exhibi-
ted with them on two occasions, but their style was not
rigourous enough for him, nor did they in turn quite
approve of what he was up to. Even Zola, the champ-
ion of Impressionism and Cézanne's childhood friend
(they both came from Aix), was perplexed by his work.
Cézanne was lucky enough to be financially independ-
ent. Leaving Paris and the almost universal incompre-
hension of his work behind him, he moved to the
South of France where he pursued his aims on his own
for the best part of his life. He gave the avant-garde of
his time a new lease of life that would lead to Cubism.

*For an Impressionist,
painting from nature is
not painting an object,
but painting his own
sensations.*

Cézanne

Cézanne built his paintings

Still life: Apples and Oranges, detail.

The round profile-less fruit stabilize a strangely crumpled cloth and a dangerously tilted ◄ table.

Before Cézanne came onto the scene, artists generally agreed that there was a reality, and they searched for different means of putting it across. For Cézanne, on the other hand, it was painting in itself that constructed a form of reality using its own components.

Look at his touch: it is very visible, but it does not "follow" the contours of the painted object. One gets the impression that it "builds" the objects, but this kind of construction can turn out to be quite whimsical. For instance, the pattern of the carpet is geometrical on the right, as if it had been woven with brush-strokes, but on the left it is full of arabesques.

There are even some objects in the painting that cannot be identified: that rounded white shape on the left can hardly be a fold in the table-cloth, and it is only barely reminiscent of a piece of broken crockery. We are equally puzzled by that area just below it, between the tablecloth and what we assume to be the edge of the table...

watch out for the colours

Colour also plays an important role in Cézanne's paintings. It is usually faithful to the real colour of objects, though it does not exactly separate the apples from the oranges. Besides which, the "white" tablecloth is in fact made up of a whole patchwork of them. This use of

When colour is at its richest, then form has reached its plenitude.

Cézanne

▲

Paul Cézanne in Provence Photograph.

His easel and his paint-box on his back...

Cézanne
Woman with a coffee-pot (c. 1890/95).
Oils on canvas:
130 x 96 cm.

We find the same instability in this painting: a table at an unnatural angle, a cup seen from above, tilted lines in the wood panelling. ◀

▲
Still life: Apples and Oranges, detail.

colour leads us astray in this painting. It is because the same range is used for the piece of carpet on the right as for the one on the left, that we believe it is one and the same carpet, despite the different patterns. By the same token, it is because that rounded shape that is so hard to identify is the same colour as the tablecloth or one of the plates, that we are so unsure of what it might be.

the glimmer of an idea

Cézanne believed that an artist should not just be a passive onlooker, and that he had to build his painting. He was guided by what he once called "the glimmer of an idea" which only surfaced when he was almost hypnotized by interminable hours of observation. This explains why he preferred to paint landscapes and still lifes — living models were too mobile!

This is why he abandoned his portrait of Vollard after no less than 115 two- or three-hour sittings…. The painting was never finished: "Please bear with me, Mr. Vollard, I have the glimmer of an idea, but I cannot express it. I am like someone who has a gold coin he is unable to spend." He added: "I am not entirely dissatisfied with the front of the shirt." This was because the shirt, though it reflected facets of light, was more stable than the mobile face of its wearer!

Astonishingly well-finished still lifes, unfinished objects made extraordinary by their wildness and personality. I think all this will be misunderstood.

Pissarro, 1895

99

Cézanne and Cubism

Cézanne always emphasized the flattening of the motif and the relief in the brush-work when constructing a painting. In *The Bathers*, he used a pyramidal composition, but it was back-to-front, as it were. This style of composition was usually used to bring out the main subject and give an illusion of space around it. Cézanne did the opposite, placing his bathers and the trees at the edges of a landscape. The painting itself, his touch, is so visible, however, that this landscape does not look as though it were in the "background", quite to the contrary, it rises to the surface of the canvas.

Cover of the catalogue for Cézanne's exhibition at Vollard's gallery in 1898.
▼

like a canvas on a wall

The table in *Apples and Oranges* looks as though it were toppling over, the white table-cloth and the carpets also "hang" vertically. In *Woman with a coffee pot*, the woman's knees are not shown. Cézanne compressed the shapes to underline the fact that a painting is a canvas that hangs vertically on a wall.

His touch also emphasizes this. Cézanne wanted his brush-strokes to be independent of what they were depicting. In *Mount Sainte Victoire*, we see the beginnings of an even, almost square touch whose only

▲
Ambroise Vollard
Photograph.
Art dealer and
publisher (1868-1939).

▲
Pablo Picasso
*Les Demoiselles
d'Avignon* (1907).
Oils on canvas:
250 x 230 cm

Facets flattened
onto the plane
of the canvas.

Cézanne
Mount Sainte Victoire
(1904/06).
Oils on canvas:
60 x 72 cm.

A masonwork of
brush-strokes in order
to show everything. ▶

variation is in the angle at which it is placed. Cézanne painted this mountain over sixty times! There is a wide, open space between the painter and the mountain, and a wide, open sky above it. This was ideal for experimenting with every possible variation of the oblique brush-stroke, bearing in mind that it was supposed to show many different objects without being forgotten in itself, and without losing its systematic regularity.

reality in facets

Cézanne's touch has been compared to brick-work, but at the same time, they seem to shimmer, as if they were a multi-faceted surface. It was this aspect of his painting that the Cubists would develop.
Five days before his death, Cézanne wrote to his son: "All my contemporaries are s*** compared to me. . . . I believe that the young painters are much more intelligent." Cézanne died in 1906, having earned the admiration of Picasso, Braque, etc. In 1907, Cubism made its bow with *Les Demoiselles d'Avignon* by Picasso.

**A belated
recognition**
Cézanne lived in the
South of France and
painted many of its
landscapes. During the
last years of his life, he
was visited by artists
who had at last
recognized his
importance.

101

A step by step analysis

TOULOUSE-LAUTREC

In 1895, Toulouse-Lautrec painted two billboards for
the fairground booth of the cabaret performer Louise
Weber, better known as "La Goulue" (the Loud-mouth).
To understand the artistic interest of these panels, all
we have to do is review all the points raised in the pre-
ceding chapters: the support, the touch, colour, move-
ment, space, etc.

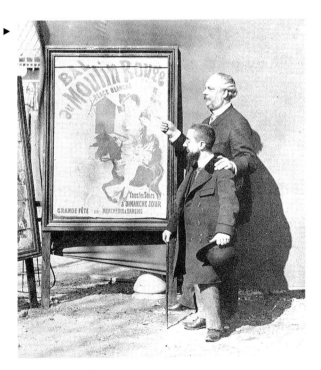

Toulouse-Lautrec with ▶
the Director of the
Moulin-Rouge.
Photograph.

Toulouse-Lautrec
spent a lot of his time
in this famous
Montmartre dance-
hall in which La
Goulue had worked
before her decline.

(following pages) ▶
**Henri de Toulouse-
Lautrec**,
French painter
(1864-1901).
The Moorish dance or
The Almehs (1895).
285 x 307 cm.
*Dancing at the Moulin-
Rouge* (1895).
298 x 316 cm.
Oils on canvas.

103

The pianist and some of the faces border on caricature: Lautrec stimulates our imagination.

The dispersion of touches of acid-green in various spots unifies the surface of the canvas.

The colour of the skirt does not follow its contours: this gives it a feeling of movement.

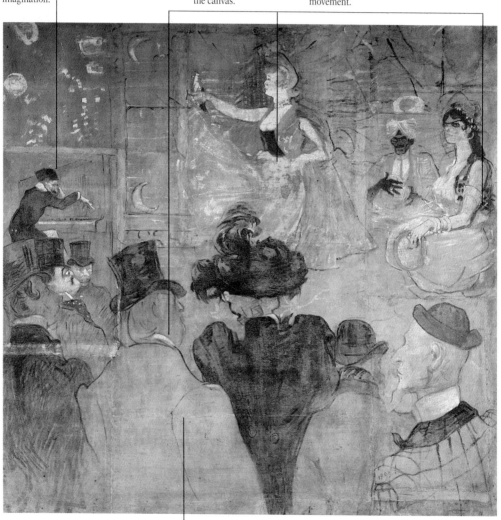

The jute canvas is left bare: the artist relied on our imagination to "fill-in" the blanks.

The framing makes us into spectators seated in the second row, which gives the impression of depth.

Besides this, the lack of detail and the fact that only the dancers are colourful, lead us "into" the scene.

The lines and the diminishing sizes of the figures provide depth. The white patches at the top are projectors directed at us, which serve to include us in the painting.

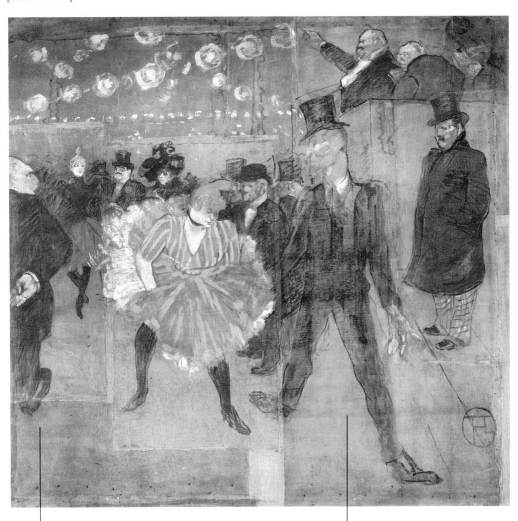

The framing cuts people off as if they were just entering or leaving the scene, which gives an impression of movement. This kind of framing, which is very exaggerated here, had been used in painting for a long time. It would later be imitated by photographers. The postures are exaggerated and unstable, which again gives the impression of movement.

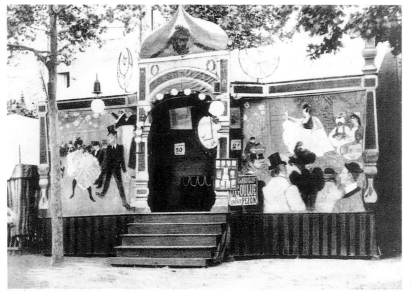

La Goulue's fairground booth at the Foire du Trône.
Photograph.

La Goulue was an exquisite dancer at the age of twenty, but she soon descended into alcohol and drugs. Prematurely aged at 25, she was no longer hired by the better-known cabarets. It was then that she asked Toulouse-Lautrec to decorate her booth at the *Foire du Trône.* ◀

Toulouse-Lautrec ▶
La Goulue (c. 1892).
Drawing:
39 x 24 cm.

The painter met the dancer in Montmartre. La Goulue was sixteen when Toulouse-Lautrec painted her portrait for the first time. Their friendship was still close when he painted the two billboards, for he gave them to her as a gift.

▲
Toulouse-Lautrec
Self-portrait.
Drawing.

A bone disease during adolescence left him a dwarf 1, 42 metres tall.

◀ **Toulouse-Lautrec**
*La Goulue and
Valentin le Désossé*
(1894).
Drawing:
29,8 x 23 cm.

Toulouse-Lautrec was
self-taught. After a
short spell in the
ateliers of two official
painters, he pursued
his training in the
cabarets and haunts of
ill-repute in
Montmartre.

▲
Toulouse-Lautrec
Jane Avril (1893).
Lithograph.

Toulouse-Lautrec did
the portraits of many
other dancers of the
period.

Toulouse-Lautrec ▶
*La Goulue and Môme
Fromage* (1892).
Lithograph.

Toulouse-Lautrec
not only lived in
Montmartre, he
shared its inhabitants'
joys and sorrows: his
illness led him to
alcoholism, and he
became a lover of
night-life. He did not
care about making
reality pleasant — but
was life pleasant for
him? And yet he is not
a real caricaturist.

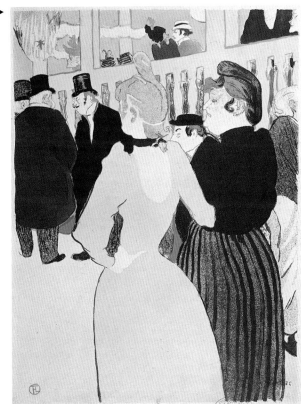

Chronological table

	POLITICAL EVENTS	ARTISTIC EVENTS
1848	February: Revolution, King Louis-Philippe abdicates, proclamation of the Republic whose President, Louis-Napoleon Bonaparte, nephew of Napoleon I, is elected in December.	Birth of Gauguin. A few landscape artists decide to paint in the open-air: they are the Barbizon School, to whom the Impressionists will be very close at first. At the Brasserie Andler, the Realist club gathers together painters (Courbet, Daumier), writers (Champfleury and the philosopher Proudhon), and poets (Baudelaire).
1849		
1850		Ingres is elected President of the École des Beaux-Arts.
1851	2 December: Louis-Napoleon stages a coup d'état and seizes full powers.	The architect Praxton builds the metal and glass Crystal Palace for the London Universal Exposition.
1852	2 December: Louis-Napoleon proclaims himself Emperor and takes the name of Napoleon III.	
1853	Haussmann, who will radically alter the city of Paris, becomes Prefect of the Seine, a post he will keep until 1870.	Courbet: scandal of *The Bathers*. Birth of Van Gogh. The architect Baltard begins the construction of the metal and glass Grandes Halles, the market of Paris.
1854	Beginning of the war in Crimea between France and Russia (to 1856).	
1855		Paris Universal Exposition. Ingres and Delacroix retrospectives. Courbet organizes his own exhibition, the "Realist Pavilion."
1857		Champfleury publishes *Realism*.
1859	Napoleon III amnesties the 1 800 political prisoners, among them Victor Hugo and Edgar Quinet, who refuse to be amnestied.	Birth of Seurat. Charles Blanc starts *La Gazette des Beaux-Arts*. Delacroix paints the murals in the Church of Saint-Sulpice in Paris
1861	France goes to war with Mexico (to 1867).	The architect Hittorf builds the Gare du Nord in Paris. Charles Garnier begins building the Paris Opera.
1862		Meeting of Monet, Renoir, Sisley and Bazille, the core of the Impressionist movement.
1863	Victor Duruy appointed Minister of Public Education: he increases the number of primary schools and opens them to girls.	Death of Delacroix. Napoleon III creates the "Salon des refusés", where all those who have been rejected by the official Salon can exhibit their work: Manet is among them.

WORKS MENTIONED	SOCIAL EVENTS

1848 Daumier, *The Republic nourishes its children and educates them.*

There are a number of writers and scientists among the deputies of the provisional government: the poets Hugo and Lamartine, the astronomer Arago, etc. The poet Baudelaire mans the barricades.

1849 (49/50) Courbet, *Funeral at Ornans.*

1850 Corot, *A morning. Dance of the Nymphs.*

Félix Potin opens his celebrated grocery chain.

1851

Repression of the Left: Victor Hugo flees to Belgium.

1852

The first department store, *Le Bon Marché*, opens its doors.
There are a little over 3 000 km of railway tracks in France, compared to the 18 000 km there will be by 1870.

1853 Chassériau, *The Tepidarium.*
Courbet, *Portrait of Bruyas.*

Victor Hugo's *The Punishments* banned in France.

1854 Courbet, *Portrait of Champfleury.*
Ingres, *Virgin with a Host.*

Foucault experiments: discovery of light-waves.

1855

Establishment of the department store, *Les Grands Magasins du Louvre*.
Victor Hugo moves to Guernsey.

1857

Baudelaire publishes *The Flowers of Evil*, which is immediately condemned as immoral.

1859

Darwin publishes *The Origin of the Species*: the species evolve by adaptation to the environment and the survival of the fittest.

1861

1862

Publication of Victor Hugo's *Les Misérables*.

1863 Manet, *Luncheon on the Grass.*
Manet, *Olympia.*
(*circa*) Daumier, *The Washerwoman.*

Creation of the *Crédit Lyonnais* bank.

POLITICAL EVENTS	ARTISTIC EVENTS
1864 The workers win the right to strike. Founding of the First Worker's International in London (disbanded in 1876).	Birth of Toulouse-Lautrec.
1865	Manet: scandal of *Olympia*.
1866	
1867	Death of Ingres.
1868 The French section of the First International dissolved.	Birth of Vuillard.
1869	The sculptor Carpeaux produces a group, *The Dance*, for the Paris Opera: it is considered to be scandalously realistic, but is left in place.
1870 19 July: war between France and Prussia. Napoleon III falls and the Republic is declared.	The country is at war: Pissarro and Monet flee to England, Cézanne stays in the South of France, Renoir is mobilized and Bazille is killed.
1871 March to May, the Paris Commune: the population of the city rises against a Republic mostly run by Royalists; the army crushes the uprising. 10 May: Peace with Prussia.	Courbet is elected a Deputy of the Commune of Paris and helps to bring down the column in the Place Vendôme. Monet moves into his "floating studio" on the Seine at Argenteuil, in which he will live until 1878.
1874	First Impressionist exhibition at the photographer Nadar's establishment: among them are Monet (*Impression: Sunrise*), Pissarro, Renoir, Sisley, Berthe Morisot, Degas, Cézanne, etc.
1875 The Assembly votes in the "Constitution of 75."	
1876 General elections, victory of the Republicans: President MacMahon dissolves the new Chamber of Deputies.	Second Impressionist exhibition: Caillebotte (also a collector) exhibits with them.
1877 Fresh general elections: the Republicans win again.	Third Impressionist exhibition. Death of Courbet.
1878	Seurat enters the *École des Beaux-Arts*. Davioud and Bourdais build the Trocadero Palace.
1879 The Republicans are in the majority in the Senate. The 14th of July is made into the National public holiday.	Fourth Impressionist exhibition: Gauguin exhibits with them. Death of Daumier.

WORKS MENTIONED	SOCIAL EVENTS
1864	Creation of the *Société Générale* bank.
	The Pope condemns the secularity of the French State, the freedom of the press and liberty of conscience.
1865	Establishment of the department store, *Les Grands Magasins du Printemps*.
1866 Courbet, *Covert of roe-bucks*. Manet, *The Fifer*.	Mendel's theories on heredity.
1867 Carpeaux, *The Berezowski bombing*.	Death of Baudelaire.
1868 Manet, *Émile Zola*. (68/69) Degas, *The Orchestra of the Paris Opera*. (68/69) Millet, *The Spinner*.	Creation of worker's insurance funds in case of accident or death.
1869 Delaunay, *The Plague in Rome*.	The Belgian, Gramme, invents the dynamo, which can produce electricity. Opening of the Suez Canal.
1870 Fantin-Latour, *An atelier in Batignolles*.	
1871 Whistler, *Portrait of the Artist's Mother*.	
1874	
1875 Caillebotte, *The Floor planers*. (75/77) Cézanne, *The Bathers*.	
1876 Renoir, *The Swing*.	Bell invents the telephone. End of the First International.
1877 Monet, *Gare Saint-Lazare*.	
1878 Monet, *Rue Montorgueil*. Sisley, *Snow scene at Louveciennes*.	Edweard Muybridge succeeds in breaking down the movements of a galloping horse with his system of multiple photography.
1879	Birth of Albert Einstein. Jules Ferry is Minister of Public Education. He will fill a number of powerful posts up to 1895, and bring in major reforms.

POLITICAL EVENTS	ARTISTIC EVENTS
1880 Amnesty for those condemned after the Commune.	The State abandons the administration of the official Salon; the Society of French Artists is founded.
1881 Free instruction in primary schools is decreed.	Birth of Picasso.
1882 Primary school is made obligatory for all children aged 6 to 13; the teaching is secular.	Cézanne leaves Paris to live in Provence. Toulouse-Lautrec arrives in Paris.
1883	Death of Manet. The novelist Huysmans publishes his studies on modern art. The first skyscraper is built in Chicago, USA.
1884	Seurat exhibits *Bathers at Asnières*: Pointillism unites Signac, Cross, Pissarro, etc. Founding of the *Salon des Indépendants*, at the initiative of Seurat.
1886	Gauguin spends three months in Pont-Aven, Brittany. The critic Félix Fénéon publishes *The Impressionists*. Last Impressionist exhibition, which includes Seurat and Signac. Van Gogh arrives in Paris.
1887	Beginnings of Art Nouveau (motifs and shapes derived from plants) in the decorative arts.
1888 The Panama Company goes bankrupt.	The Nabis form round Sérusier: Maurice Denis, Bonnard, Vuillard, Ranson, etc. Van Gogh moves to Arles, where Gauguin visits him: they quarrel.
1889 Founding of the Second International in Paris (dissolved in 1914).	A group of dissatisfied members quits the Society of French Artists and found the *Société Nationale des Beaux-Arts*, with its own exhibition.
1890	Van Gogh moves to Auvers-sur-Oise, where he commits suicide.
1891 Panama scandal: the Parliamentary Right accuses the Left of having taken bribes in return for favouring financial transactions aimed at saving the Panama Company.	Gauguin leaves for his first stay in Tahiti. Death of Seurat.
1892	Monet begins his *Rouen Cathedral* series.
1894 A Jewish officer, Captain Dreyfus, is unjustly accused of high treason and imprisoned.	Beginning of the Caillebotte affair when the State refuses the bulk of his bequest. It will last until 1897.

WORKS MENTIONED	SOCIAL EVENTS
1880	
1881 Pissarro, *Young girl with a stick*. Puvis de Chavannes, *The Poor Fisherman*.	
1882	
1883	The Frenchman Desprez invents the electric cable.
1884	Workers obtain the Right of Assembly, which enables them to form unions.
1886 Degas, *The Tub*.	New York receives Frenchman Bertholdi's giant statue, *Liberty Lighting the World*.
1887 Van Gogh, *Père Tanguy*. Van Gogh, *The Italian woman*.	
1888 Cazin, *The Day's End*. Sérusier, *The Talisman*.	The Frenchman Forest develops the use of petrol in the combustion engine.
1889 Gauguin, *La Belle Angèle*. Van Gogh, *Self-portrait*.	
1890 Van Gogh, *The Church of Auvers*. (90/95) Cézanne, *Woman with a coffee-pot*.	There are now 35 000 km of railway tracks in France.
1891 Seurat, *The Circus*. Vuillard, *In Bed*. (91/92) Cross, *The Golden isles*.	
1892 Gauguin, *Arearea*.	The Dutchman Lorenz discovers electric atoms: electrons.
1894 Vuillard, *The Conversation* Vuillard, *The Red Sunshade*. (*circa*) Bonnard, *Child making a sand-castle*.	

113

POLITICAL EVENTS	ARTISTIC EVENTS

1895

Invention of cinema by the Lumière Brothers.
The construction of the Eiffel Tower begins (finished in 1889).

1897

Rodin sculpts a statue of Balzac, which marks the birth of modern sculpture.

1898 Émile Zola becomes involved in the Dreyfus affair and attacks the Government in the daily newspaper *L'Aurore*. The country will be split in two by this issue, which is mainly the result of anti-semitism.

The Architect Guimard designs the famous Art Nouveau entrances to the Paris Metro.

1901

Death of Toulouse-Lautrec.
Picasso's Blue Period (up to 1904).

1902

The Perret Brothers build the cement apartment block with visible ossature in the Rue Franklin, Paris.

1903

Founding of a new Salon in Paris, the *Salon d'Automne*, with the participation of Vuillard.

1904

1905 Law separating the State from the Church.

Picasso's Pink Period (up to 1907).
The Fauves at the *Salon d'Automne*: Matisse, Marquet, Derain and Vlaminck totally abandon the real colour of objects.

1906 Rehabilitation of Dreyfus.

Death of Cézanne.

1907

Cézanne retrospective at the *Salon d'Automne*.
Beginnings of Cubism.

WORKS MENTIONED

SOCIAL EVENTS

1895 Toulouse-Lautrec, *The Moorish Dance*
Toulouse-Lautrec, *Dancing at the Moulin-Rouge*.
(1895-1905) Cézanne, *Still life: Apples and Oranges*.

1897 Lévy-Dhurmer, *The Angry Wave*.
Vallotton, *The Ball*.

1898 The French couple Pierre and Marie Curie isolate the first radioactive substance: radium.

1901 Paris-Berlin automobile race: the winner, Fournier, covers the 1 198 km in 16 hours and 6 minutes.

1902

1903 Redon, *Portrait of Gauguin*.

1904 Cézanne, *Mount St-Victoire*.

1905 Matisse, *Luxe, Calme et Volupté*. Einstein formulates his theory of relativity: mass and energy are
Redon, *The Chariot of Phaëton*. everything, matter is concentrated energy.
(*circa*) Redon, *The Buddha*.

1906 Derain, *Charing-Cross Bridge*.

1907 Douanier Rousseau, *The Snake Charmer*.
Picasso, *Les Demoiselles d'Avignon*.

Biographical notes

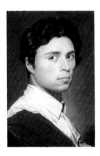

INGRES

DAUMIER

▦ French painter born in Montauban in 1780, died in Paris in 1867.

▦ He received his training in Paris from 1797, in the atelier of the celebrated Neo-classical painter David, who immediately discerned his gifts. In 1801, he graduated from the École des Beaux-Arts with the first prize.

▦ He traveled to Italy in 1806, and stayed there for 18 years, regularly sending paintings back to Paris that scandalized the critics with their originality.

▦ In 1824, his talent was recognized at last and he returned to Paris where he began a brilliant career. He was received by the Academy, taught at the Beaux-Arts and painted numerous portraits and large murals such as the *Apotheosis of Homer* on a ceiling in the Louvre. He went back to Italy to direct the Academy of France in Rome from 1834 to 1841. He was awarded the Legion of Honour in 1855, and became a Senator in 1862.

▦ A prolific worker, he produced countless masterpieces. The Louvre possesses many of them (*Madame Moitessier* and *The Turkish Bath*, for example) and his birthplace has also consecrated a richly-endowed museum to him. *The Spring*, a painting which was received with enthusiasm, is also in Musée d'Orsay. Ingres had a tyrannical and sometimes destructive influence over a whole generation of painters: he demanded a blind submission that led his students to hate him at times. He has often been compared unfavourably to Delacroix.

▦ French caricaturist, painter and sculptor born in Marseilles in 1806, died in Valmondois, near Paris, in 1879.

▦ His family moved to Paris in 1816. Daumier had a varied apprenticeship: drawing in minor ateliers (*circa* 1822), lithography (1825).

▦ From 1830, he became a regular contributor to the satirical weekly *La Caricature*, even spending a few months in prison in 1832 because of a caricature of the King! From 1833 he contributed to *Le Charivari* and continued to express his Republican views on the many occasions provided by the political events of the times.

▦ He took up painting in 1848. Few in number and of a small size, his paintings treat a great variety of subjects, ranging from *The Tumblers* to an *Entombment of Christ*, from *The Thieves and the Ass* (illustrating a fable by La Fontaine) to *Don Quixote* (illustrating Cervantes' epic).

▦ He began to lose his sight in 1877 and was no longer able to work, but the Republic gave him a pension that enabled him to retire to Valmondois.

GAUGUIN

MONET

French painter, sculptor and engraver born in Paris in 1848, died in the Marquesan Islands in 1903. He was also a prolific writer (letters, illustrated notebooks, essays).

He joined the Navy in 1865, leaving it in 1872 to become a stockbroker, as which he would earn his living for some ten years, spending all his free time painting. He was close to many artists, whose works he collected and who taught him to paint. He married in 1873, and had five children between 1874 and 1883.

He exhibited his work — a landscape — for the first time at the Salon of 1876, and was then invited by Degas to join the fourth Impressionist exhibition in 1879.

He spent three months in Pont-Aven in 1886, and met Van Gogh. During a second stay in Brittany in 1888, he met Sérusier. After that he joined Van Gogh in Arles. Theo Van Gogh paid him a monthly retainer in return for his paintings.

In 1891 he made his first stay in Tahiti, returning to Paris in 1893. He went back to Tahiti in 1895, whence he left for the Marquesan Islands in 1901.

Often ill during the last years of his life, he lived with the native populations and was in constant conflict with the colonial authorities, even attempting suicide at one point. Despite this, he was very productive, and sent many paintings, drawings, engravings and sculptures back to the art dealer Vollard in Paris.

He was much admired by his contemporaries and, in the year he died, Vollard held an exhibition of 50 of his works, while the *Salon d'Automne* consecrated an entire room to his paintings.

French painter born in Paris in 1840, died in Giverny in 1926.

He was already famous for his caricatures as an adolescent. He attended the *Académie Suisse* in Paris, but he soon abandoned any training and took up painting in the open air, persuading the other future Impressionists to join him!

He was a refugee in London during the Franco-Prussian war of 1870 and, when he returned to France he settled in Argenteuil, near Paris, living in a "floating studio" on the river.

It was his painting, *Impression, Sunrise*, exhibited at the Photographer Nadar's establishment in 1874, that gave the Impressionist movement its name. Monet would exhibit with them up to 1880.

He had a predilection for outdoor subjects, whether it be the countryside (*Women in a garden*, 1866, Orsay), the seaside (*The Cliffs at Pourville*, *The Beach of Sainte Adresse*) or even the city (*Rue Montorgueil*, *The Railway bridge at Argenteuil*, 1873). He was the first artist to paint series on a single theme that varied according to the season or the time of day (the *Gares*, the *Cathedrals*, the *Haystacks*).

Monet's home at Giverny (not far from Paris), in which he received many visitors, has been restored and is open to the public.

DEGAS

SEURAT

▨ French painter, sculptor, pastellist and photographer, born in Paris in 1834; his death in Paris in 1917 went almost unnoticed, because of the war and also because he had ceased painting in 1910 due to blindness.

▨ The son of a banker, he began by studying law, abandoning it in 1855. He joined the class of one of Ingres' pupils, attended the Beaux-Arts, and visited Italy, where he had some relatives.

▨ His interest in Japanese prints led him to question conventional perspective: he liked unusual "angles" and impossible "mirror effects."

▨ It was thanks to this shared interest in space and movement that he exhibited with the Impressionists from 1874 to 1886. He himself painted somewhat smoothly, and never worked in the open air.

▨ Like many of the artists of his period, he was particularly interested in subjects that excluded the spectator: opera and ballet (there are many of his *Dancers* in Musée d'Orsay), but also the races (*At the Races*, 1877/80, Orsay). He was also one of the rare painters who was interested in the subject of labour (*The Laundresses*, 1884, Orsay) and in showing women in unconventional situations: washing (*The Tub*, 1886, Orsay), or even drinking (*Absinthe*, 1873, Orsay).

▨ He worked extensively in pastels, but he also took photographs and, at the end of his life, because of his blindness, he took up sculpture.

▨ French painter born in Paris in 1859, died in the same city in 1891.

▨ The son of a process-server, he went to the Beaux-Arts in 1878, studying under one of Ingres' pupils. But he was interested above all in Chevreul's theories on simultaneous contrast.

▨ He was admitted to the Salon of 1883, but in 1884 his *Bathers at Asnières* was refused. It was then that, along with others who had been "refused", he formed the *Société des Artistes Indépendants*, which held its own annual exhibitions. In 1886, he showed his "manifesto-painting", *La Grande Jatte*, at the last Impressionist exhibition. He had made no less that 23 drawings and 38 preparatory oil-sketches for this work!

▨ He became the leader of the Pointillists, but only other artists appreciated their work: the critics were very hostile.

▨ Seurat died very young, having produced a few paintings on the subject of shows : *Le Chahut* (1889/90) and *The Circus* (1890/91). His theories would be of great value to his contemporaries and to many artists of the 20th century.

COURBET

MANET

▓ French painter born in Ornans (Eastern France) in 1819, died in Tour-de-Peilz (Switzerland) in 1877.

▓ The son of a landowner, he began studying drawing while he was still at secondary school. He moved to Paris in 1840, abandoning his law-studies for painting. He worked in the Louvre and attended the Académie Suisse, where he practised life-drawing. In 1844, he was admitted to the Salon for the first time. He was to become a regular contributor of landscapes, seascapes, etc.

▓ From 1848, at the Brasserie Andler, he met with the other future Realists, among them the writer Champfleury. Some of his paintings began to cause scandals (*Funeral at Ornans*, *Young Women on the Banks of the Seine*, 1857, etc.). In 1855, he held his own exhibition at the Universal Exposition after it had rejected some of his paintings.

▓ In 1861, he established an atelier in Paris which attracted about 40 students (including Fantin-Latour), but he soon grew tired of it! He had many shows of his paintings in the provinces and during his travels abroad.

▓ In 1870, he refused the Legion of Honour. At the fall of the Empire, he was part of a committee of artists entrusted with the protection of works of art. During the Commune, of which he was elected a member on 16 April 1871, he helped bring down the column in the Place Vendôme.

▓ He spent six months in prison when order was re-established, and was freed in March 1872. He emigrated to Switzerland in July 1873, and ended his life there, a prolific worker to the end.

▓ For a long time, the scandals surrounding Realist subjects prevented one from truly appreciating Courbet's painting: his treatment of paint (sometimes with his palette-knife) and his frequently acid colours were admired by all of the avant-garde artists of the period.

▓ French painter born in Paris in 1832, died, totally paralysed, in the same city in 1883.

▓ His father was a magistrate who encouraged him to study law, but Manet ran away to sea for six months. On his return, he attended the *École des Beaux-Arts*, studying under one of the most conservative painters, Couture. Very soon — in 1856 — he abandoned his studies and traveled to Holland, Germany and Italy.

▓ *Luncheon on the Grass*, 1863, and *Olympia*, 1865, were both rejected by the official Salon and shown at the Salon des Refusés, where they raised a scandal nevertheless. Depressed by this, Manet spent several months traveling in Spain.

▓ He met the Impressionists and Émile Zola at the Café Guerbois. He supported them, but did not exhibit with them. Rejected by the Universal Exposition of 1867, he held his own exhibition.

▓ His subjects were very varied: portraits (*Portrait of Zola*, 1867/68, of *Mallarmé*, 1876), still lifes (*The Asparagus*, 1880), simple open-air scenes (*On the Beach*, 1873, Orsay), the pleasure haunts of the period (*Music in the Tuileries*, 1860, *The Races at Longchamp*, 1864, *Masked Ball at the Opera*, 1873), and street-scenes (*The Pavers of the Rue Mosnier*, 1878).

▓ He developed from a very smooth, flat style, partly inspired by Japanese prints, to a faster, freer touch, at times very similar to that of Monet.

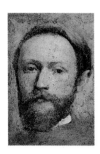

VUILLARD

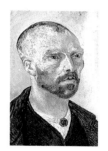

VAN GOGH

▨ French painter born in central France in 1868, died in La Baule in 1940.

▨ His family moved to Paris when he was ten: his father was a retired sea-captain. Vuillard met Maurice Denis and Roussel while they were at school together in the Lycée Condorcet. Roussel studied art, and Vuillard abandoned his plan to go to the military academy of Saint-Cyr to follow him.

▨ They attended a number of independent academies and, in 1888, they met Bonnard and Sérusier: the Nabis had formed.

▨ Vuillard was attracted to large mural paintings and to the minor arts (posters, theatre programmes, sets, etc). He would continue as a painter long after his Nabi period. Shortly before his death, he decorated the headquarters of the League of Nations in Geneva and the Chaillot theatre in Paris.

▨ At the turn of the century, Vuillard, like Bonnard, joined the Fauvists, then he developed into an Intimist painter (portraits, etc) and became more easily accepted by the fashionable clients he sought.

▨ From 1899, he exhibited regularly in his dealers the Bern-heim brothers' gallery, but also in the *Salon des Indépendants* and the *Salon d'Automne,* of which he was one of the founders in 1903.

▨ He became a member of the Academy in 1937.

▨ Dutch painter: though he was born in Brabant in 1853, he spent his entire painting life in France and committed suicide in Auvers-sur-Oise, not far from Paris, in 1890.

▨ He was the son of a pastor and undecided about his future. Successively disappointed in love, in his attempt to become a pastor like his father, and other objectives, he finally took up art and moved to Paris in 1886.

▨ Incapable of staying put in any school of art, he met up with Gauguin and Toulouse-Lautrec. After the populist sub-jects he had painted in Holland, treated with thick strokes of sombre colour (*The Potato Eaters*, 1885), he lightened his palette upon discovering the Impressionists.

▨ He settled in Arles in 1888, painting landscapes, still lifes (*Sunflowers*) and portraits (*L'Arlésienne*).

▨ Gauguin joined him in Arles, but they quarreled, as a result of which Van Gogh cut off the lobe of his ear. Suffering from persistent hallucinations due in part to his chronic alcoholism, he was interned in 1889/90. He worked continuously neverthe-less (*Self-portrait with a bandaged ear, Yellow wheat with cypresses,* etc).

▨ In 1890, in order to be closer to his brother Theo, he moved to Auvers-sur-Oise, where he was looked after by Doctor Gachet, an alienist and the friend of many artists (Pissarro, Cézanne, etc). He continued to paint prolifically (two canvases a day on average): *The Church of Auvers, Wheat field with crows,* etc.

▨ The *Fauves* greatly admired his treatment of colour, and the thickness of his touch would be imitated by all the Expressio-nist movements.

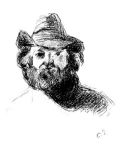

CÉZANNE

TOULOUSE-LAUTREC

French painter born in Aix-en-Provence in 1839, died in the same town in 1905.

He was the son of a banker. After he abandoned his law studies with his father's permission, Cézanne went to Paris to attend the *Académie Suisse* where he met the future Impressionists in 1861. He was to show his work at the first and third of their exhibitions (1874 and 1877). In 1882, he was accepted by the Salon for the first and last time!

He left Paris to return to Aix in 1881, he had the reputation of being antisocial, and his father made him an allowance that dispensed him from having to sell his paintings. He preferred working from life, and even Zola, his childhood friend from Aix, did not understand what he was doing! He worked extremely hard, with obstinacy and in some desperation, for he believed he was a failure.

In 1895, Vollard organized his first personal exhibition. Cézanne occasionally spent a week or two in Paris, where people were beginning to realize that he was a genius. He showed his work at several independent exhibitions (the "Salon des 20" in Brussels, the Salon des Indépendants of 1899 and 1901, the "Salon de la Libre Esthétique" in Brussels of 1901 and 1904).

Cézanne is considered the founder of modern art. It was his style of brush-work that inspired the "facets" of Cubism, and the way he compressed space in his paintings led artists even further away from the illusion of space and forced the spectator to become aware of the painting as an object once and for all.

French painter and poster-artist born in Albi in 1864, died in the Gironde in 1901.

He was of noble descent, but his father was an eccentric who took no interest in a son who had been left a dwarf by a childhood illness. Left to himself, Lautrec was able to follow his bent. In 1882 he settled in Paris, abandoning the Beaux-Arts as soon as he discovered the Society of Independent Artists: Van Gogh, Gauguin, etc, but above all, as soon as he discovered Montmartre!

He had no interest in Nature, preferring the world of shows, prostitution, and the street. It was from there that he drew all his subjects.

He was very interested in what are called the "applied arts": posters, magazine covers, book illustration. In 1899, he illustrated Jules Renard's *Histoires Naturelles*.

An incurable alcoholic — he even hid alcohol in his hollowed-out walking-stick — he suffered an acute attack of *delirium tremens* in 1899 which led to his being interned for a cure that failed: he died shortly afterwards at the age of 37. Irritated by the slowness of his son's funeral cortege, his father whipped the horses and forced everyone to run to the cemetery!

The "casualness" of his style of painting is misleading: Lautrec brought a new way of organizing objects in space and a great economy of touch to painting.

Glossary

Académie Suisse
Private art academies made their appearance in the 19th century, as a reaction against the constricting official teaching of the period. The first of these was the *Académie Suisse*, founded by an artist's model of that name. *Académies* were studios at which an artist could spend the day drawing from life, often for free. They had no teachers as such, but many of them were supervised by reputable painters who encouraged the artists to express themselves fully.

Aesthetics
A branch of philosophy that examines the reasons why a work of art is called "beautiful" or "interesting" at a particular moment in history. The term is used to describe specific doctrines (for example: Romantic aestheticism). The expression "it is aesthetic" used to mean "it is beautiful" is therefore wrong.

Atelier
An artist's studio or workshop in which several assistants or apprentices contributed toward the execution of a work bearing a master's signature, and in which students of art received instruction from the master.

Canvas
Stiff, tight-woven fabric made of linen, cotton or hemp used as a support in painting.

Charcoal
Also called fusain, the charcoal pencils or sticks used for drawing are derived from the fusain or spindle tree.

Chiaroscuro
The treatment of a painting in terms of light and shade, especially the placing of a light area between a dark foreground and a darker background to give dramatic effect and depth to a painting.

Classicism
The doctrine of artists who were inspired by Graeco-Roman art. In France it was widely followed in the 17th century.

Colour grading
The progressive alteration of the luminous intensity of a colour. A colour can be graded through all the values from light to dark. There are also ranges of colours, a range of blue, for example: cobalt, Prussian blue, ultramarine...

Complementary colours
The theory of complementary colours in painting is that the effect of a primary colour will be heightened when it is placed next to the two others united into their secondary colour. Green is the complementary of red, violet of yellow and orange of blue.

Composition
The placing of the components of the subject of a painting, the placement of the people, architecture, etc.

Divisionism
Another name for Pointillism, describing the separation of the dots of colour.

Easel
A wood support on three legs that holds a canvas at the angle of the painter's choice during painting. What are known as "easel paintings" date from the Renaissance.

Fauve, Fauvism
The word means "untamed." Fauvism was an artistic movement that arose in 1905 and was characterized by the fact that painters used pure colours and that these bore no relationship to the real colours of the objects depicted.

Frame
Frames were traditionally made of gilded wood. From the Renaissance onwards, a frame centred the spectator's attention and separated art (the painting) from non-art (the wall). Towards the end of the 19th century, some artists questioned the use of frames (see Seurat and Vuillard).

Fresco
The art of painting on freshly spread moist lime plaster with pigments mixed with a water-thinned binding material (distemper, tempera). The word has now come to mean any mural.

Glaze
A thin layer of transparent colour applied at the end of the painting process, to modify the colours and to achieve depth and transparency. The same effects are often achieved by using a lightly tinted varnish.

Gouache
Water-dissolvable paint whose pigments have been ground in water and mingled with a preparation of gum. Gouache differs from watercolour by the opacity of its colours, enabling them to be easily painted over.

Hue
Word used to describe a colour that is made by mixing colours from the spectrum, and especially the gradation of colour.

Iconography
Derived from the Greek *eikon*: image, and *graphein:* writing, iconography is the recognizable imagery selected by the artist to convey a meaning, or simply to be the subject of a work.

The meaning can include the identity of the figures or symbolic objects and animals (see Gauguin).

Iconology
Derived from the Greek *eikon*: image, and *logos*: knowledge, iconology is the study of the meaning of images in art.

Illusionism
A term used to describe any method of painting that reproduces reality as faithfully as possible, and in which the painting as an object (canvas, paints) is made to disappear. Not to be confused with Realism (see that word).

Image d'Épinal
These were simple woodcuts of the saints that became extremely popular, and were replaced after the French Revolution with portraits of prominent people and series of illustrations of historical events designed for children.
An *image d'Épinal* therefore came to mean a naïve, cartoon-like picture. The best known printing-houses were in the town of Épinal, France.

Impressionism
A major art movement of the 1860s and 1870s which owes its name to a painting by Monet, *Impression, Sunrise*, shown at the group's first independent exhibition in 1874. According to the Impressionists, the eye is in continual motion, and only really perceives pulsations of light. This meant that they rejected both the traditional perspective formulas that had been in use since the Renaissance and the Illusionist manner of painting (see Monet).

Japanism
Term used to describe the interest that every late-19th century painter showed for the Japanese prints that began to be imported in the 1860s, and the use they made of them.

Linear perspective
The mathematical construction of a painting that gives an illusion of depth through the precise calculation of the reduction in size of an object in proportion to its distance from other objects and from the eye.
The development of the laws of perspective in painting marks the passage from the Middle Ages to the Renaissance, they were then brought into question by the late 19th century artists.

Local colour
One uses this expression to describe the true colour of an object, for example: the "local colour" of leaves is green. One analyzes the way in which artists treat local colour, or disregard it (as, for example, the *Fauves*).

Modelling
To give a three-dimensional appearance and create the illusion of volume on a flat surface by subtly grading the colours.

Mythology
The word is derived from the Greek *mythos*: fable and *logos*: knowledge. Greek myths are stories about their gods and heroes.

Neo-classicism
An artistic and literary movement of the 18th and 19th centuries that revived the styles of classical antiquity. The painter David was its most famous proponent.

Neo-Impressionism
Another term for Pointillism, in regard to its attempt to systematize the Impressionism that preceded it and make it more precise in form. Not to be confused with Post-Impressionism (see that word).

Oil (paint)
Paint made of ground pigments, bound with a quick-drying oil and vehicled with a volatile medium, generally turpentine. Oil paints can be used on any support that has been suitably primed and take a year to dry fully.

"Optical synthesis"
Optic law discovered by Chevreul in 1831. The inner or central optic nerve synthesizes two or more of the six pure colours of the spectrum that produce colourless light, to arrive at every hue.

Painting
A painting is made up of four essential components: the support, the ground, the painted parts and the varnish...to which one could add the frame, since it is traditionally almost an integral part of a painting. One should not forget that a painting is a flat surface, and it is important to understand why and how an artist wished to give the illusion of depth and volume, or why and how the artists of the second half of the 19th century were less concerned by these aspects.

Palette
The word has two meanings. It can be a round, oval, or square piece of wood with a hole cut in it for the painter's thumb, onto which he disposes his paints. It also means the range of colours used by the painter.

Pastel
A stick of coloured chalk. Pastels are made of powdered colours and ground white chalk mashed into a paste with glue or gum arabic. The word also describes a drawing done in pastels.

Patina

The effect of a slow natural evolution of the painting materials that results in a slight darkening of the tones. The patina is produced by the oxidizing of oil-based bindings and the original varnish. Patina is not to be confused with the slight yellowing of varnishes.

Pentimento

Alterations made to a work in progress by the painter himself. The altered parts frequently become visible after a lapse of time.

Pigment

The basic ingredient of a colour. Whether organic (earth), inorganic (mineral or chemical), pigments are ground to a fine powder, bound with oil or glue and thinned with turpentine or water before being used in painting.

Plane

A plane is a flat or level material surface. Although the word is often used to mean a "plane of projection", which is an area that is intersected by the imaginary lines drawn from the eye to every point on an object in linear perspective (see that word), and is therefore the plane, or surface, on which the subject is painted, there can be more than one plane in a painting. So "plane" should be understood as separate surfaces arranged on a single flat surface: the support. Sometimes, planes are simple, flat, compartmentalized areas of colour.
At the end of the 19th century, Japanese prints partly inspired artists to treat their compositions in this way (see Gauguin, Degas, Vuillard).

Pointillism

This is the most commonly used term for Seurat's theory of painting (the others are: Neo-Impressionism, Divisionism, Luminism). In Pointillism the brush-stroke is reduced to a dot of one of the six pure colours of the spectrum. The optic nerve then synthesizes these dots and gives one the impression of different colours. Seurat developed his method by studying the law of simultaneous contrast.

Post-Impressionism

There are so many artists of the last quarter of the 19th century (Van Gogh, Gauguin, Toulouse-Lautrec, etc.) and so many movements (Pointillism, the Nabis, etc.) that the term Post-impressionism is often used to describe the period that went from Impressionism to the death of Cézanne in 1906. Not to be confused with Neo-Impressionism (see that word).

Primary and secondary colours

In the six colours of the spectrum, the three primary colours (red, yellow and blue) are not derivable from other colours and form the basis of every hue. The three secondary colours (green, purple and orange) are formed by mixing two primary colours in equal quantities.

Primer coat

A first coat of diluted paint uniformly applied to the canvas during the process of roughing out a painting.

Priming

A layer of a preparation such as size mixed with a pigment, spread over the canvas to be used for a painting in order to give it an even surface and prevent the paint from soaking into it. The Impressionists gave much less importance to the preparation of a canvas than their predecessors had.

Primitivism

This is not so much a movement in art as a current of thought that began with Gauguin and is still prevalent in the 20th century. It designates art for which the inspiration is drawn from primitive art or from early or faraway civilizations.

Pure colours

Colours that closely approximate the colours of the spectrum. The word is also used to describe a colour applied to the canvas "straight from the tube", that is to say, without being previously mixed on the palette.

Realism

Artistic movement of the middle of the 19th century, whose most famous representative was Courbet. Realism should not be confused with Illusionism (see that word), for it does not describe the art of giving an illusion of reality, but simply the accurate representation of what one sees, without any attempt to improve upon it or idealize it.

Retouching

Alterations made to a work by a hand other than the painter's.

Romanticism

A literary, artistic and philosophical movement originating in England and Germany towards the end of the 18th century, and a little later in France. Its most famous French proponents were Delacroix in painting and Victor Hugo in writing. This movement, which followed Neo-Classicism (see that word), abandoned Antiquity and turned towards closer sources (often the Middle Ages). Added to which, since the movement was contemporary with the development of the sciences, the Romantics no longer felt that they could depict a world that was whole and neatly laid out.
The artists frequently carried the art of the rough sketch or the incomplete fragment to extremes because they were more "evocative."

Saturation
A colour is said to be "saturated" when there is no white in its composition.

Scale of genres
Hierarchy of subjects imposed by the Academy in the 17th century, ranging from the inanimate (landscape) to the noblest human aspirations (historical painting comprising history, religion, mythology and literature) in an ascending scale, and going through all the intermediate stages: still lifes (because they were composed by human intervention) zoography (because animals are living creatures); then came the portrait and the genre or subject painting (a familiar, mundane scene, but one that involves an elaborate composition).

Scumble
A thin layer of paint applied closely with fast, irregular strokes and an almost dry brush. Scumbling frequently leaves the grain of the canvas or the preparatory drawing uncovered.

Sketch
A rough free-hand drawing giving only the essential features of a subject. Late-19th century artists often made only sketches, dispensing with more detailed cartoons and studies.

Space
One uses the word "space" when speaking of the fictitious or imaginary space filled by three-dimensional forms in a painting. One also speaks of "pictorial space" when describing the surface of a canvas. From the Renaissance onwards this space was constructed using linear perspective (see that word), but this is not the only way it can be done. The artists of the late 19th century called perspective into question, searching for other means to give the impression of space. It is possible, for example, to give the illusion of three-dimensional space by the arrangement of flat planes (see this word) on the canvas (see Vuillard).

Stippling
Applying unadulterated colours onto the canvas using small touches to blend them, as Delacroix did, rather than mixing them on the palette beforehand.

Stretcher
A wood frame on which the canvas to be painted was stretched.

Study
A drawing or painting intended as a detailed outline, that is made just before the painting proper is begun. The painter would make a number of studies of details for his final composition (heads, groups, draperies, etc.).

Support
The foundation, generally a wall, wood or canvas on which a picture is painted.

Tone
Word used in painting to describe the "lightness" of a colour ranging from very dark to very light. One also speaks of "clear" and "sombre" tones.

Touch
The way in which the paint is applied. Also the characteristic skill of an artist apparent in his brush-work.

Treatment
The specific manner or style in which an artist paints.

Value
Describes the intensity of a colour in relation to light and shadow. One also speaks of "warm" and "cold" colours.

Varnish
Varnish is obtained by dissolving a natural or synthetic resin in a volatile solvent that when spread upon the surface of a painting dries by evaporation. Varnish serves both to finish a painting and to protect it from the atmosphere.

Varnishing day
The day before the opening of an exhibition, reserved for the painter to varnish or put finishing touches to his work. Also describes a reception given on that day, as a preview to an exhibition.

Wash
Method of drawing or tinting a drawing by "washing" it with highly diluted Indian ink or any other water vehicled pigment.

Watercolour
Water-dissolvable paint whose pigments are bound with gum Arabic. Watercolours are more transparent than gouache and are used on a support of paper or card.

Photographic credits

Edited by Scorpio
Lay out : Maxence Scherf
Illustrations by Philippe Mignon
Designers : Dominique Guillaumin
and Pierre Granet
Color separation : Reproduzione Scanner
Printed by Editoriale Libraria, Italy
Dépôt légal : March 1994